Contemporary African
American cinema

The History and Art of Cinema

Frank Beaver
General Editor

Vol. 4

PETER LANG
New York • Washington, D.C./Baltimore • Bern
Frankfurt am Main • Berlin • Brussels • Vienna • Oxford

Sheril D. Antonio

contemporary African American cinema

PETER LANG
New York • Washington, D.C./Baltimore • Bern
Frankfurt am Main • Berlin • Brussels • Vienna • Oxford

45446280

10-7-02

Library of Congress Cataloging-in-Publication Data

Antonio, Sheril D.
Contemporary African American cinema / Sheril D. Antonio.
p. cm. —(Framing film; vol. 4)
Thesis (Ph.D.)—New York University, 1999.
Includes bibliographical references and index.
1. Afro-Americans in motion pictures. 2. Afro-Americans
in the motion picture industry. I. Title. II. Series.
PN1995.9.N4 A58 384'.8'08996073—dc21 00-067154
ISBN 0-8204-5517-2
ISSN 1524-7821

Die Deutsche Bibliothek-CIP-Einheitsaufnahme

Antonio, Sheril D.:
Contemporary African American cinema / Sheril D. Antonio.
–New York; Washington, D.C./Baltimore; Bern;
Frankfurt am Main; Berlin; Brussels; Vienna; Oxford: Lang.
(Framing film; Vol. 4)
ISBN 0-8204-5517-2

Cover photograph from *Clockers*; courtesy of David Lee and Spike Lee

Cover design by Lisa Dillon

The paper in this book meets the guidelines for permanence and durability
of the Committee on Production Guidelines for Book Longevity
of the Council of Library Resources.

© 2002 Peter Lang Publishing, Inc., New York

Printed in the United States of America

For my mother, my father, and my Aunt Daisy

Table of Contents

Acknowledgments

I would like to thank my department faculty, in particular my advisor, Professor Ed Guerrero, and professors Robert Stam, Robert Sklar, Toby Miller, and Richard Allen. I would also like to recognize the contribution and support of Manthia Diawara, Regina Austin, Michael Gillespie, and Ken Sweeney. Finally, this process of investigation and inquiry could not have occurred without my students, who continually challenged me and forced me to constantly review and revise my ideas.

I am most grateful to my mother, my father, Aunt Daisy, Pari Shirazi, Rachel Terte, and Cam Galano, without whom this work would not have been possible. I thank my team at the office, especially Dale, Derrick, Rosanne, Wendy, Jaqui, and Patti. Words like "support" and "encouragement" cannot define their efforts on my behalf, nor can "grateful" or "appreciative" equal my thanks. Very special thanks go to my boss and mentor Dr. Mary Schmidt Campbell, Mr. Spike Lee, David Lee, and Rod Gailes.

Chapter One

An Introduction

100 Years Later

Although Black filmmaking has participated primarily in the independent film market for the past hundred years, recent and consistent inclusion in the mainstream film industry known simply as "Hollywood" suggests a significant change in its status. Contemporary African American cinema, or Black American cinema, has made a significant place in American film history. This powerful and unique body of work, generated from the mid-1980s to the early 2000s, has become the topic of books by educators, critics, and historians. The subject has also taken root in the academy's curriculum at some of our country's most renowned educational institutions, giving African American cinema academic validity as well as much-needed exposure. To what does contemporary Black or African American cinema owe this new status? What informs and defines its aesthetics and narrative style? What are the debates surrounding its subjects, topics, and themes?

African American cinema has been in existence since the early stages of cinema itself. Oscar Micheaux produced and directed films in the silent period alongside D. W. Griffith. Working mostly as independents, Black filmmakers have endeavored to produce films for nearly a century with little or no support, financial or otherwise, and with only marginal recognition from the mainstream American film industry. In the mid- to late 1980s, however, several African American filmmakers called critical, popular, and profitable attention again to Black American cinema. This decade clearly and distinctly marked the beginning of the contemporary period of African American cinema. Leading this palpable and powerful revolution in African American cinema, an evolution in American filmmaking, was Spike Lee, who appeared on the scene from New York University's film

school, with his first independent feature, *She's Gotta Have It* (1986). Lee, arguably the strongest and most consistent force in this movement more than a decade later, still offered the best examples of range and diversity in theme in contemporary African American cinema. His film *He Got Game* (1998) establishes hope in the same urban streets that saw only death and despair in the early 1990s.

Many Black directors emerged to make Hollywood and its intended audiences, film critics, theorists, educators, and historians take notice of the style, aesthetics, themes, and perspectives of contemporary African American cinema. Robert Townsend, John Singleton, the Hudlin Brothers, Mario Van Peebles, Earnest Dickerson, Julie Dash, Leslie Harris, the Hughes Brothers, Bill Duke, Charles Burnett, Marlon Riggs, and others have given new life to popular Black American cinema and a new face to American film. Informed by diverse and seemingly contradictory influences in terms of social and historical priorities, African American cinema struggles to make its perspectives widely available to audiences who will take the time to look and listen. In plain and simple terms, African American cinema explores, through its own version of an American art form, how the priorities on the national agenda are expressed, mediated, amended, and experienced, based on race, gender, and class.

This book will examine six of the films in the contemporary period, dating from 1991 to 1995. These films have established profound connections not only with Black audiences, agendas, and communities, but with a diverse mainstream audience as well. They are Mario Van Peebles' *New Jack City* (1991), John Singleton's *Boyz N the Hood* (1991), Ernest Dickerson's *Juice* (1992), Leslie Harris' *Just Another Girl on the I.R.T.* (1993), the Hughes Brothers' *Menace II Society* (1994), and Spike Lee's *Clockers* (1995). These films were selected because they represent popular contemporary works, because they exhibit qualities that define and dominate this period of African American filmmaking, and because they each use media as a pivotal narrative element, connecting each work to established American mainstream forms and formulas.

Contemporary African American cinema's ability to sustain itself in strictly financial terms is critical to its development, growth, and continued existence in the flow of mainstream media. "Profitable," then, in both practical and artistic terms, is an important distinction. The success of one film or filmmaker directly impacts those who follow. By no means can we ignore the fact that films are funded, produced, and distributed in the context of a business or industry. Although this is the case for all films and filmmakers, African American directors face particular and unique concerns related not only to box office receipts but, more specifically, to

crossover appeal. In this latter arena, however, Black films have been able to do more than just make money to sustain their own momentum. Ed Guerrero, referring to both the Blaxploitation period of the 1970s and the contemporary period, says that "Both black film waves arose during periods of economic crisis and downturn in the film industry earnings."[1] 1971's *Shaft*, directed by Gordon Parks, Sr., for example, is not only credited with inaugurating the Blaxploitation period, but also with "saving" MGM from bankruptcy. Donald Bogle notes that "MGM thought *Shaft* might make a little bit of money. Of course, it made a mint and helped keep MGM in business."[2]

In recent years, fiscal matters have become more intricate for Black directors entering the commercial film industry, but, fortunately, the contradictions and debates have become more public as well. These matters, and the details and controversies surrounding them, are now frequently discussed in the media and related academic texts. Contemporary African American cinema's willingness and ability to publicly navigate this issue has in many ways contributed to its success. A 1991 issue of *Sight and Sound* attempted to deal with the real question in the ongoing debate. That question is whether or not Hollywood's resources ebb and flow, with race among other criteria often used to keep the marginalized in their place. It will come as no surprise that there are essentially two sides to this debate. One is occupied by Black directors who hold the strong opinion, supported by "facts," that the industry is racist; another is occupied by industry executives who say it is not—supported by more "facts." Here, from the business section, we get one perspective. "How racist is the industry? Hollywood is neither white nor black; it's green."[3]

Without a doubt, 1991 was a remarkable and noteworthy year for African American films and filmmakers. Here it was finally, proof that profit, and not race exclusively, was more the motive for deciding which films would be made. From this particular vantage point, then, one could assume that more films would be made because contemporary African American cinema was now popular, critically acclaimed, and making money. The box office reports were in, and the future seemed bright. The hope was that this boom would continue and, eventually, as the movement reached a plateau, Black directors would continue working on a variety of projects. Black-focused films would become a regular occurrence in American filmmaking on both the independent and commercial fronts. "Back in the 'hood and Hollywood, no less than 19 films by black directors were released that year."[4] However, according to Guerrero, the view of the future from the late 1990s might not be so bright without a necessary evolution of the genre, which he insists is possible. The

movement's decline, then, in popular and profitable terms, might be closer than we expect. "So as the end of the decade, century, and millennium approaches," he notes, "the most obvious genre to exhaust itself is the ghetto-action-gangsta flick."[5] If his forecast is at all correct, then, Black American film history will be repeated, and we could look to the developments that led to the end of Blaxploitation to chart this boom's decline. But still larger questions loomed. Would the events in 1991 mark a significant turning point for African American cinema? What would 1991's production peak and the subsequent years yield for the movement in aesthetic terms?

Both fans and critics of contemporary African American cinema note that, with few exceptions, the dominant themes are male-focused and commercial and that the films are planted firmly in the streets of Black neighborhoods. Henry Louis Gates, Jr., confirms this observation, locating the origin of the trend in the Blaxploitation era. "From that day to this," he notes, "there persists the notion that 'authentic' African-American culture is to be found only on the streets of inner cities."[6] Unfortunately, Gates looks exclusively at Black influences in order to contextualize the films in the contemporary period. It is the goal of this book, however, to trace the roots deeper. While one task will be to distinguish these films from dominant American cultural formations, we will simultaneously be connecting them to the formula known simply as the American gangster film. Through this process, both the originating formulas of the film and each film's unique style will be apparent. This will expose and highlight each film's aesthetic inventiveness and reveal the complex nature of their social commentaries and critiques.

Contemporary African American cinema is also criticized for the fact that Black women, as film directors or as central characters, are not well represented. This remained unchanged until late 1991. Audiences waited until that pivotal year before they could experience the work of a Black woman on the popular and commercial scene: Julie Dash's *Daughters of the Dust*. It was not until two years later, in February 1993, that the *New York Times* could proclaim, referring to the number of Black women making feature films, "In the next two months, the most exclusive club in movies will triple its membership."[7] Audiences were even more surprised in 1994 to learn that Darnell Martin was the first African American woman to direct a picture (*I Like It Like That*) for a Hollywood studio. In other words, she was the first Black woman to make a fully financed or studio feature. How could this be interpreted, given the fact that we had seen several films directed by Black women already? The terms "released" and

"funded," as they relate to the film industry, represent very different fiscal arrangements. "In fact, the only film directed by a black woman financed by Hollywood is "A Dry White Season, an anti-apartheid movie starring Donald Sutherland, Susan Sarandon and Marlon Brando. Released in 1989 by MGM, it was made by Euzhan Palcy, a native of Martinique, not an African American."[8]

Black women as central characters showed some popularity in the late 1990s. Two important examples, *Waiting to Exhale* (1996) and *Set It Off* (1996), managed to revive some of the agenda items left by *Daughters of the Dust* and *Just Another Girl on the I.R.T.*, except for one. Neither of these films is the product of a Black woman director; *Waiting to Exhale* was directed by Forest Whitaker, and *Set It Off* by F. Gary Gray. Clearly, credit must be granted for the handling of the material in these very different films, but the question remains, Why are there are so few Black women directors on the commercial scene? When, if at all, will this change?

Before posing questions and delving into what informs and defines African American cinema's narrative style or aesthetics, it should be restated that, as a whole, this is a movement primarily concerned with Black American characters, and their stories. The perspectives, priorities, and agendas offered here are defined by the specific historical conditions that exist in the United States. This is a cinema that has as its goal the prioritization of images representing Black American life in American mainstream media. Given the social, political, and economic history of Blacks in this country, often reflected in the posture of American media in general, one can easily comprehend the impetus African Americans have, as marginalized Americans, to create new, more inclusive, and even exclusive images. These images, by their very existence, counter the perspectives of the mainstream or dominant media. Once distributed, these new images would address, whether directly or indirectly, the way Blacks have been represented in and by mainstream media these past hundred years.

As we will invoke more general theories of marginalization throughout our discussion of contemporary African American cinema, it should be stated that the post-slavery condition reflected here cannot be defined adequately by post-colonial or immigrant theories devised to define the circumstances of stereotyping, disenfranchisement, or alienation. Indeed, Black Americans share similarities with immigrant populations in the United States, but as Ella Shohat and Robert Stam note, there are significant differences as well: "Stereotypes of Polish-Americans and Italian-

Americans, however regrettable, have not been shaped within the racial and imperial foundation of the U.S., and are not used to justify daily violence or structural oppression against these communities."[9]

African American cinema is not a cinema devised solely to present new solutions to, or a platform for, the positive-negative image debate plaguing Black American art for the past hundred years. For Manthia Diawara, the "problem" of Black images in film is not necessarily solved by "positive" images, whether created by Blacks or Whites, or the so-called inclusive trends visible from time to time in American mainstream cinema.[10] These strategies actually contribute to the problem. The solution, according to Diawara, is a presentation of Black culture, as well as Black characters in film, that bears some resemblance to real life, not stripped of its texture and intensity, in order to ease an unfamiliar or uncomfortable White audience. Without this texture, these films do little toward informing or mediating the political, economic, social, and artistic boundaries faced by Blacks in America on a daily basis. Diawara continues his point by arguing that, without these textures, mainstream media is actually "keeping the real contours of the Black community outside Hollywood."[11]

Understanding that new, true-to-life images of Black Americans are desired, and in fact necessary, one must then ask how these "counter" images are constructed. In order to examine these issues, one must excavate roots from the whole of cinema, and not just Black American cinema. Once the parameters for the discussion have been established, we can then ask how effective the films are in achieving their self-described goals. We know that one goal of African American cinema is to give Black Americans, their history, their social and political agendas, and their perspectives some presence or priority, if not equality, in the mainstream media. This visibility would signify self-proclaimed validity.

I will argue that the films to be discussed here, while, on the surface, must depart from the Hollywood agenda and customs to realize their goals, are nonetheless informed by its formulas and styles. The link that I will make will be primarily to the American gangster film. I will make a more significant point that will relate to the fact that footage from these antecedent gangster films exists in the narrative structure at pivotal moments. While this is not a new revelation, the idea has not been given significant time and attention in a way that posits African American cinema as American cinema. Clearly, according to Robert Sklar, many of these films were "firmly located in the crime genre (scenes with 1930s gangster classics playing on television were emblematic in several of these

films)."[12] In the end, the arguments and examples presented in this book will make a solid, undeniable, and, I hope, unbreakable bond between African American and American cinema. The most critical point, which both Sklar and Guerrero note, and which I will present here in great detail, is related to violence and its frequent occurrence in these films. What Sklar outlines quite effectively is the origin of this often criticized element of African American cinema. He does so by linking the genre to the classic Hollywood formula it emulates. "The violence and sexism of black male youths in these films," Sklar points out, "were indeed as vivid and controversial as similar behavior of Irish or Italian mobsters portrayed by Cagney, Robinson and Muni decades earlier."[13] This removes the narrative use of violence from an ethnic or racial context and posits it in the larger American gangster genre or formula. Guerrero relates this to Houston Baker's notions of "mastering the master's form."[14]

Media as Mediation

The six films selected for this exploration use media as a central narrative element. However, one can also observe the use of media in general as a broader trend in African American cinema. Several landmark films in the same period make use of various forms of mass media as a core narrative element or device. Both Dash's *Daughters of the Dust* (1991) and Lee's *Do the Right Thing* (1989), for example, use photographs as a topic or central theme. Much time is spent in both films either discussing or producing photographs that have a significant effect on the characters and story. In fact, their existence is critical to the narrative.

In this broader view of contemporary African American cinema, the notions embedded in intertextuality and reflexivity present at least one interpretation of the frequent use of media in these films. Looking at the success rate of this chosen tool, enlisted by different directors and used in different ways to realize their goals, a larger trend is evident. While the end product—what I will call the media moment—may be easy to recognize on screen, I will explore why these reflexive or intertextual moments have been constructed and the significance their placement has on each film. As the authors of *New Vocabularies in Film Semiotics* state: "Intertextuality is a valuable theoretical concept in that it relates the singular text principally to other systems of representation rather than to an amorphous 'context' anointed with the dubious status and authority of 'the real' or 'reality.'"[15]

In *Daughters of the Dust*, the main action takes place in a single day, although the story seems to cover an eternity in Black history. The film is about a Black family on the eve of a migration from the Carolina Sea Islands north to the U.S. mainland. The events are captured by two distinct cameras: one, the obvious, but invisible, director's camera, and another, the visible (still) camera. This second lens or frame belongs to one of the film's characters, Viola's friend, the photographer Mr. Snead. His narrative presence, his obvious camera, and the notions of seeing invoked by his presence offer another perspective of the events taking place. For example, it is Snead who "sees" the unborn child while in the process of making a family portrait on the beach. Toni Cade Bambara discusses the significance of the photographer in this film: It is "to call attention to the fact that in conventional films we're seduced by technique and fail to ask what's being filmed and in whose interest, and by failing to remain critical, become implicated in the reconstruction/reinforcement of an hierarchical ideology."[16] I suggest that the notion of remaining critical in relation to media images is the agenda of the intertextual and reflexive moments in African American cinema in general.

In *Do the Right Thing*, much time and energy is spent on the photographs of the Italian Americans hanging on the wall in Sal's Pizzeria, located in a Black neighborhood of Bedford-Stuyvesant in Brooklyn. The photographs used by the Italian characters, like the music used by the Black characters, draw and defend cultural or ethnic lines. The battle between these two American ethnicities exists because they are forced by the narrative to exist in the same space, as is often the case for many such groups in real life. The photographs represent an ethnic fortress that Sal has built around the physical and emotional space of his pizza parlor; the character Radio Rahim and his music represent an assault on these ethnic buttresses, which provides Buggin' Out a platform to fight for photographs related to his community. He insists that photos of Blacks replace Sal's selection of Italians. He asks, "Hey Sal, how come you don't have no brothers on the wall?" It is clear that the photographs represent a vehicle used to navigate the specific issues in the film. They also reflect very real concerns some members of American society have about space and who occupies it, as well as the dissemination of images and issues of representation. Shohat and Stam note that this conflict "vividly exemplifies this kind of struggle within representation."[17]

Other films that use media extensively, or are about media and the related issues of representation, are *Hollywood Shuffle* (1987) by Robert Townsend and *Color Adjustment* (1991) by Marlon Riggs. In *Hollywood*

Shuffle, Townsend uses his comic talents to construct a narrative fiction that explores representations of Blacks from an actor's point of view. In *Color Adjustment*, Riggs uses the documentary form to chart the history of Black images on American television while exploring the social and aesthetic controversies that arise from these images.

Color Adjustment presents numerous images to viewers and, as we interact with them, we are encouraged to enjoy them. We are also encouraged to acquire a much deeper understanding of how depictions of Blacks, even so-called positive ones, are counterproductive or have severe limitations. What Riggs wants us to understand, for example, is that when we laugh at J. J. from the television show *Good Times*, we should also be aware of the association his character has to the stereotypical buffoon. It is Riggs' intention that we understand that this is a historical reference with roots that lead back to the time of minstrels, blackface, and even the horrific images of Blacks presented in *The Birth of a Nation*. Remain critical of images of Blacks in the media, Riggs asserts, and like Townsend, he clearly wants his audience involved, informed, and, by film's end, armed with the skills to be critical viewers. Most essential for Riggs is that the audience be alert. He admits, "I wanted the audience to work."[18]

There were several layers to the well-orchestrated and profoundly realized visual argument in the presentation of *Color Adjustment*. On one level, the clips were entertaining; on another, they represented a historical record of images and (mis)representations of Blacks. In combination, they are provocative, critical, and, of course, challenging to viewers because Riggs constantly shifts the viewers' relationship to the images and their position as spectators. Because there were so many complicated paths to his point, Riggs himself notes that some may have eluded viewers. "I guess," he explains, "I was counting on a much more critical viewing than occurred."[19]

Hollywood Shuffle's unique approach encourages the viewer to transcend the role of spectator and take part in the decisions facing Black actors when auditioning for "Black" roles in Hollywood. Like Riggs in *Color Adjustment*, Townsend varies our viewing position in order to pose questions. Who decides what Black is? How is Blackness constructed in a character? Are these renditions acceptable? More importantly, these films converse with the viewer by using established media forms; using, in other words, the very instrument being critiqued to address their concerns. Therefore, they encourage, and in fact, train viewers to look beneath the surface of images in order to become more critical observers. The issues raised in both films are crucial to our main theme. In each

case, media is used to realize the film's individual goals—media used to critique media.

This book will focus on six popular films in contemporary African American cinema that use film and television as an important link to, and, at the same time, criticism of, mainstream American media and the society it represents. This examination, which evokes and relies on notions of reflexivity and intertextuality, will uncover contemporary African American cinema's well-stated critique of the larger American society and the status of Black life in that context. As we witness African American cinema's battle to extend beyond the margins onto the page, we will examine why African American directors, in creating Black-centered images, have, with some regularity, selected intertextuality and reflexivity as preferred and effective tools to transmit their critique.

Not a Separate Cinema

Finally, I will argue that contemporary African American cinema is *not* a separate cinema. This brings the realities and importance of crossover appeal and marketing to our discussion. "In today's film industry," notes Jesse Algeron Rhines, "crossover refers to the potential of a film addressing nonwhite Americans' concerns to secure a significant financial return from white American viewers."[20] African American cinema is a cinema that has been able, while informing, mediating, and at times entertaining audiences, to contextualize its form and themes in mainstream American film history. Although each director has devised aesthetic styles and notions of his or her own that can move easily between independent and mainstream modes of production, we are clearly dealing with an American phenomenon. While the priorities of African American cinema remain the production and dissemination of Black images, ideas, and concerns, the contemporary movement has also realized a complex and powerful American aesthetic style, one that can, and, in fact, does appeal to mainstream audiences. While this mainstream appeal offers Black filmmakers the prospects of continued opportunities, there are very real artistic considerations for Black filmmakers looking to secure financing for their films. "Culture and finance are intimately interwoven within the crossover concept," Rhines continues, "and because whites control film financing, nonwhite filmmakers must consider their film's crossover potential to attract white private financing."[21]

In a section of his book titled *Watching Race: Black Popular Culture and the Cultural Politics of Difference*, Herman Gray offers a context for our investigation of those issues related to crossover. "By the 1980s,"

he writes, "these complex social and cultural questions were debated and enacted in such public cultural arenas as commercial network television, films, novels, popular music, and cultural criticism."[22] The term "crossover" in this context means cross-marketing. This meant that directors and their films had to validate and pursue several agendas at the same time. How then, given this multifaceted public, can difference be constructed without judgment? More importantly, asks Gray, "Would representing these complex differences amount to airing dirty laundry, in effect fueling stereotypes and eroding black political power, social legitimacy, and cultural visibility?"[23]

This presents a far more complex dilemma for contemporary African American filmmakers. Given Gray's point, would Black directors now face the risk of causing more harm than good? Must they also struggle with their notions of "truth" or "real" and whether or not the positive-negative image debate about Blacks in the media should mediate their artistic notions and endeavors? African American cinema in general cannot focus solely on countering the stereotypical expectations of a diverse mainstream audience. There is diversity within the Black community. The concern is obvious. What happens when this diversity is unfolded onto a larger social, political, and artistic arena? And, finally, can contemporary African American cinema resolve these tensions?

Contemporary African American films have indeed achieved mainstream crossover status, but, clearly, profit is not the only motive for focusing on the importance of the wide circulation of Black images. What mainstream distribution provides is a vast and varied public platform for the perspectives, debates, and critiques embedded within each film. The longevity of African American cinema is tied in many ways to its ability to appeal to mainstream audiences, which means its ability to make money. Crossover status has many advantages, including financial, of course. However, for the purpose of future discussions on how media mediates differences, there are some aesthetic and cultural disadvantages that have been raised by the filmmakers themselves. Given the difficulties Black filmmakers have in finding adequate funds for their films, it should come as no surprise that, as Peter Biskind writes, "Executives are increasingly worried that the African American audience is not big enough to support black films at the profit margin to which they have become accustomed. Hence the 'cross over' to the white audience is perceived as more important."[24]

Setting aside the financial benefits and pressures attached to mainstream appeal, there are other concerns about the industry's preoccupation with crossover for African American films. In these comments by Peter Biskind, the realities facing Black filmmakers are evident: "'Cross-

over' is a dirty word with many black directors. They are concerned that as their budgets go up, they'll be pressured to play down the tougher, more abrasive, quintessentially black elements of their films in the interest of attracting white audiences."[25] Is this the price of assimilation? Striving for, gaining, and maintaining this status, then, holds different meanings for different people. For Black directors, it relies on authenticity, which translates as integrity, and for the industry executives it means mainstream marketability. Can these two sides work together and devise a system that supports the needs of both? Or will assimilation simply mean the telling of stories with Blacks but not necessarily about the real nature of Black existence?

The films under consideration here do indeed present hard-hitting arguments and pose difficult questions to everyone, Blacks and Whites alike. It is interesting to note here that five of the six films on my list are debut films. What they offer can easily be described as "new," and we can also employ often overused terms such as "fresh" or "raw" to describe their individual points of view. In many ways these films represent the earliest utterances from Black filmmakers on the way toward assimilation into Hollywood's mainstream culture. As debut features for all of the directors, except Lee, they seem to contain original forces unmediated by issues such as those outlined by the positive-negative image debate or the politics of crossover marketing. While this conversation suggests significant investment in the auteurist approach, which, in John Caughie's definition, recognizes "the artist whose personality was written in the film,"[26] to pursue it would be exhaustive, and discoveries would offer no simple key to the film text.

Setting the auteurist approach aside is also valid in the examination of African American cinema. Roland Barthes' notions offer us a radical and fitting perspective for cinema in general. "To give a text an author," he claims, "is to impose a limit on that text, to furnish it with a final signified, to close the writing."[27] His idea that I favor most is that "the birth of the reader must be at the cost of the death of the author."[28] It is this point of view that acknowledges and empowers a diverse mainstream audience in the complex scenario presented by crossover marketing. In this instance, alienation is minimized and everyone is encouraged to take part in the process and eventually in the ongoing debate. This enables media to mediate.

Most will agree that the issues in each film discussed here are rooted in this country's racial, political, economic, and artistic history. Indeed they are, yet they also offer audiences alternative versions of this history, which, in turn, offer a more complex view of contemporary Black life and the art

that emanates from that life. What the films have brought to the mainstream is a closer look at the lives of people never before prioritized in American media and the nature of their individual circumstances. One such point is well made in this statement by the producers of *New Jack City*, Doug McHenry and George Jackson:

> The "*New Jack*" philosophy is to give it to you straight, no chaser. The tension that underlies much of our daily life is the rage of a generation left behind. In an article on this page, the historians Neil Howe and William Strauss explained how the 13th generation of Americans may have missed out on the American dream. This is certainly the case for the 13th generation of African Americans. Born after 1960, they have witnessed the murders of Malcolm X and the Rev. Martin Luther King Jr., the beginning and the end of the war on poverty, and the AIDS and crack epidemics. They may be the first generation of African Americans who do not have a dream.[29]

While many of the objectives of African American cinema may be clear, there is still much room to explore aesthetic choices and tools. Remain critical. Each of these six films in contemporary African American cinema insists we keep this in mind. The tools used in the execution of each director's task will stand as a self-proclaimed and self-realized link to American cinema and media in general. This book will be written from the perspective of a media consumer who celebrates African American cinema by selecting what is distinct about each individual director and effective about each individual film. It will focus on an analysis of each media event or citation that occurs within the film text where a character intersects with a visible or implied film or television medium as part of the film's narrative structure. This analysis will begin within the film text, from the position of Black American cinema looking out. The position of the film as a whole will be derived from the information found in the text. In other words, we will uncover where the film places itself in the larger context of American life as well as in American media in general.

The analysis of each film will also reveal a "double" spectatorship perspective derived from W. E. B. Du Bois' notions of "double consciousness." Paul Gilroy uses Du Bois' notion in his book *The Black Atlantic*, giving it a context necessary for our analysis of the films. "Double consciousness," he states, "was initially used to convey the special difficulties arising from black internalization of an American identity."[30] Gilroy's identification of the "post-slave" condition is an essential defining element for the American environment, one that affects everyone, oppressor and oppressed. Such systematic and long-term abuses leave residual infrastructures, many of which have been unearthed by the films.

The analyses will center on main characters and how they reveal their individual sense of doubleness within the narrative structure and in conjunction with the media event. Through these analyses, we will be given the opportunity to observe the character's ability to observe the self as "other," or, in effect, explain how they are perceived by society, and even explain how they are conscious of being "watched," "policed," or "omitted" from the dominant media and culture. The arguments will posit African American cinema as a cinema that is self-conscious if you will, aware of being observed, not only by movie audiences who could retrieve obvious messages, but by American society.

Sterotypes Old and New

While the focus of this book is on the contemporary period in African American cinema, it is critical that we highlight several landmark moments in the larger historical context. Black films, in the early years, were generally made for Black audiences. Thomas Cripps provides a clear account of the history of Black images, marking the beginning of Black genre film near the time of *The Birth of a Nation*. By all accounts, including Cripps', Oscar Micheaux was deemed the "father" of African American cinema. Here he gives us an important starting point, a definition of Black film that is essential for our discussions about the contemporary period:

> For the purpose of this study, "black film" may be defined as those motion pictures made for theater distribution that have a black producer, director, and writer or black performers; that speak to black audiences or incidentally, to white audiences possessed of preternatural curiosity, attentiveness, or sensibility toward racial matters; and that emerge from self-conscious intentions, whether artistic or political, to illuminate the Afro-American experience.[31]

Cripps makes it clear that quarrelling over the minute details of a definition can be, and in fact is, counterproductive. In other words, African American cinema's validity must be recognized, even if it is supported by White money. Cripps also identifies and outlines the importance of W. E. B. DuBois' double consciousness and its relation to the contradictions embedded in any definition of African American cinema. "It describes," he says, "the anomaly of American racial arrangements, which segregate black from white, discriminate along racial lines, and yet oblige Afro-Americans to assimilate the values of white America."[32] It is this double consciousness, or divided awareness, that persists as a theme in contem-

porary African American cinema, brought to the foreground, I will argue, by the intertextual and reflexive moments.

No contemplation or exploration of contemporary African American films and their relation to mainstream cinema and audiences can be undertaken without Donald Bogle's *Toms, Coons, Mulattoes, Mammies, and Bucks*. This book gives an astonishing and informative history of Black stereotypes in film from the beginning to the 1960s, but more importantly, it provides a sense of the impact these early stereotypes had, and still have, on Americans, Black and White. Bogle provides definitions and examples of the most popular and, of course, the most destructive stereotypes, found so deeply rooted in American culture and its film history. Here, too, we see that *The Birth of a Nation* holds a place of distinction. "With *The Birth of a Nation* in 1915, all the major black screen types had been introduced,"[33] Bogle writes.

For almost one hundred years, Black images in mainstream American media have indeed been troubling. Knowing the origins, progression, and evolution of these stereotypes is essential, particularly for debating counter-images. The early years of American filmmaking helped prepare, encourage, and clarify the agenda of contemporary African American filmmakers. Whether audiences were witnessing the misrepresentation or exclusion of Black characters in mainstream media, the images provided an impetus not only for the Blaxploitation period, which saw the emergence of the Black male hero, but for contemporary African American cinema as well. Although the Blaxploitation period displayed some union between Black artists and Hollywood, the results would prove disappointing and, in the end, problematic for many years. This era essentially planted false hopes in Black audiences tired of the usual Hollywood fare of the 1950s and 1960s.

Unfortunately, the promise of cinematic integration and strong, independent Black characters was not to be fulfilled. Audiences, feeling empowered by these initial landmark films, would go again and again to the theaters hoping to recapture the mood. Hollywood, making careful note of the interest, quickly set the production machine in motion to continue making films, which, in their estimation, were serving the needs of Black people. Not long after, audiences abandoned the formula, as it had clearly lost its original appeal. Nelson George notes the impact of this era on individual filmmakers in a brief but powerful summation: "For black filmmakers, *Sweetback* is a vital memory of what could be, and its bastard child blaxploitation is a bitter reminder of what to avoid."[34]

It is essential to ascertain how the contemporary period fares in terms of stereotypes. For many, the "types" or stereotypes of Blacks have not disappeared. They would argue that new types or stereotypes, found in contemporary Black films, have simply replaced old ones. In his article, "Buppies B-Boys, Baps and Bohos," George describes four new types in African American cinema, noting that "Group self-definition is always tricky. It's easy to turn people into caricatures or distort the complexity of individual experiences."[35] Since contemporary African American cinema often takes the perspective of the young Black urban male, it is not surprising that the B-boy "type" dominates the movement. "The B-boy has rightfully been the most celebrated and condemned of these figures, since he combines the explosive elements of poverty, street knowledge, and unfocused political anger," George continues. "B-boy style has flowed far from its ghetto base and affected language, clothes, music, and damn near everything else."[36] George pinpoints the introduction of these four types, and, ironically, marks their debut in the film that is credited with kicking off the contemporary period of African American cinema—Lee's *She's Gotta Have It*. The four types he describes are "B-Boy Mars Blackmon, Boho Nola Darling, Bap Greer Childs, and embryonic Buppie Jamie Overstreet."[37]

It is important to keep the goals of this book in mind.

A) It focuses almost exclusively on films in the contemporary movement (1991–1995) that achieved mainstream, or crossover, status and critical acclaim.
B) It is a work that focuses on African American cinema's prioritization of Black images, perspectives, and priorities while using or invoking American media, specifically film and television, as an element of the narrative structure. In other words, I will allow the text to give the discussion the initial direction.
C) It posits African American cinema as American cinema, delving into what that means in terms of the forms and formulas the works emulate, along with the resulting aesthetic and political posture.

The analysis will be fashioned after the visual techniques discovered in my viewing of Riggs' *Color Adjustment* (1991). I hope to mimic, in writing, his visual style, moving between the images of the film and the media images or references in the film. I will punctuate the dialogue with critical analyses, and constantly shift the position of the viewer/reader to encourage a deeper understanding of the film text. More importantly, like

Riggs, I will keep the text as the centerpiece of my arguments. The goal here is eventually to expose a variety of positions within the text, at times visible within the same character in a given film. This will give the viewer or reader some sense of double consciousness. For example, a film may move from the point of view of a Black character in his or her circumstances, then shift to an observer, Black or not, who may not occupy the same position in relation to the narrative activity. In addition, great effort will be made to vary the position of the individual readers to encourage them as future viewing audiences and readers to become more aware of how the media transmits meaning. It is my hope that they will observe characters watching themselves or images they wish to emulate and explore what intertextuality and reflexivity mean, not only in terms of the film in general, but in terms of the characters involved in the narrative. In essence, I will explore how meaning is constructed by the use of these elements. The chapters devoted to the individual films will emphasize these moments and examine them at length, paying close attention to the intended meaning of the intertextual and reflexive refrain, which is to remain critical of media images of all kinds.

The aim of this endeavor is not to be judgmental about the works in particular or of contemporary African American cinema in general. It is not an effort that will assign negative value to the images, or assess and identify what is "lacking" in the contemporary African American cinema. In other words, it will not fall prey to the unproductive forces in the positive-negative image debate that regularly condemn African American films, filmmakers, and their themes. Rather, this exploration will identify, enhance, magnify, and deconstruct the visual sequences that were constructed by each director to make a statement about contemporary African American life. I will look at each film and each character's relationship to American film and television media in general. I will examine the use of reflexivity and intertextuality in African American cinema as a way to comment on its own structure and relationship to mainstream American media. I will explore what remaining critical of media means to each individual director and character where appropriate. Great effort will be made to encourage viewers and readers alike to understand how some of the images, at times appearing stereotypical in the context of the positive-negative image debate, can have new meaning. Ours will be primarily a task of textual analysis, although the approach may vary, given the actual demands of the film text or what is suggested or alluded to by the individual text. This analysis must pay close attention to the images as they present themselves and to assign some meaning as originally con-

ceived and contextualized by the film itself. As the interweaving of relevant criticism and analysis progresses, this will permit the reader, in each case, to experience a variety of interpretations or readings. It will be essential to ensure that the goals of contemporary African American cinema, and the construction and dissemination of Black images to mass audiences, are kept in mind throughout these analyses. We will have to take great care in understanding how each individual director accomplishes the specified goals, using a medium already fraught with encoded difficulties. Like many of the ideas and notions brought forward here, this is not new. In a passage from her book *Playing in the Dark*, Toni Morrison explains this notion in relation to literature and her own work.[38]

Notes

1 Ed Guerrero, *Framing Blackness: The African American Image in Film* (Philadelphia: Temple University Press, 1993), 164.

2 Donald Bogle, *Blacks in American Film and Television* (New York: Simon & Schuster, 1988), 186.

3 Peter Biskind, "The Colour of Money," *Sight and Sound* (August 1991):6.

4 Richard Setlowe, "Shiftin' Gears, Movin' out of the Hood: Black Filmmakers Expanding Horizons—and Expectations," *Daily Variety,* 8 October 1993, 11.

5 Ed Guerrero, "A Circus of Dreams and Lies: The Black Film Wave at Middle Age", in *The New American Cinema*, ed. Jon Lewis (Durham: Duke University Press, 1998), 336.

6 Henry Louis Gates, Jr., "Must Buppiehood Cost Homeboy His Soul?" *New York Times*, 1 March 1992, sec. H, p. 11.

7 Bronwen Hruska and Graham Rayman, "On the Outside, Looking In," *New York Times,* 21 February 1993, p. 17.

8 Ibid.

9 Ella Shohat and Robert Stam, *Unthinking Eurocentrism* (New York: Routledge, 1994), 183.

10 Manthia Diawara, "Black American Cinema: The New Realism," in *Black American Cinema,* ed. Manthia Diawara (New York: Routledge, 1993), 11–12.

11 Ibid., 12.

12 Robert Sklar, *Movie-Made America: A Cultural History of American Movies* (New York: Vintage, 1994), 349.

13 Ibid.

14 Guerrero, *Framing Blackness,* 182.

15 Robert Stam, Robert Burgoyne, and Sandy Flitterman-Lewis, *New Vocabularies in Film Semiotics* (New York: Routledge, 1992), 205.

16 Toni Cade Bambara, "Reading the Signs, Empowering the Eye: *Daughters of the Dust* and the Independent Cinema Movement" in *Black American Cinema*, ed. Manthia Diwara (New York: Routledge, 1994), 133.

17 Shohat and Stam, *Unthinking Eurocentrism*, 183.

18 Kalamu Ya Salaam, "Marlon Riggs," *Black Film Review* 7, no. 3, 7 (1992), 7.

19 Ibid.

20 Jesse Algeron Rhines, *Black Film/White Money* (New Jersey: Rutgers University Press, 1996), 70.

21 Ibid.

22 Herman Gray, *Watching Race: Television and the Struggle for "Blackness"* (Minneapolis: University of Minnesota Press, 1995), 46.

23 Ibid.

24 Biskind, "The Colour of Money," 6.

25 Ibid.

26 John Caughie, "Introduction," in *Theories of Authorship*, ed. John Caughie (New York: Routledge, 1981), 9.

27 Roland Barthes, "The Death of the Author," in *Theories of Authorship,* 212.

28 Ibid., 213.

29 Doug McHenry and George Jackson, "Missing the Big Picture," *New York Times*, 26 March 1991, sec. A, p. 23.

30 Paul Gilroy, *The Black Atlantic* (Cambridge: Harvard University Press, 1993), 126.

31 Thomas Cripps, *Black Film as Genre* (Bloomington: Indiana University Press, 1978), 3.

32 Ibid., 5.

33 Donald Bogle, *Toms, Coons, Mulattoes, Mammies, and Bucks* (New York: Continuum, 1991), 17.

34 Nelson George, "Buppies, B-Boys, Baps, and Bohos," *Village Voice,* 17 March 1992, 26.

35 Ibid.

36 Ibid.

37 Ibid.

38 Toni Morrison, *Playing in the Dark: Whiteness and the Literary Imagination* (New York: Vintage, 1992), x–xi.

Chapter Two

New Jack City

Mario Van Peeples, 1991

"I have the unusual situation in that I'm a second-generation filmmaker and for black folks that's pretty rare."[1]

Mario Van Peebles

New Jack City's director Mario Van Peebles is the son of Melvin Van Peebles, a "folk hero"[2] of the Black film community. Unlike many African American directors, he perceived his circumstances as fortunate when embarking upon his feature film career. In other words, he felt empowered as an artist. "I have the advantage," said Mario, "that almost by osmosis I have more of a perspective."[3] The perspective Mario Van Peebles speaks of is informed by the knowledge, skills, and experiences gleaned over two generations in filmmaking. His inheritance is from two branches, or facets, of American film history: classical Hollywood cinema, and through his father, Black independent filmmaking. For the younger Van Peebles, however, the art of directing would not solely be confined to, or by, his race. "I had been directing 'Jump Street,' 'Top of the Hill,' 'Wise Guys'—doing a lot of episodic [TV]," he recalled in an interview with Jacquie Jones. "So that I defined myself as a director prior to Hollywood defining me as a *Black* director."[4] How did this self-defined and confident practitioner tackle the challenge of his first feature, *New Jack City*, an explosive modern-day gangster film? How would his influences be revealed, and what techniques would he employ to transmit the film's socially conscious message?

The legacy bequeathed to Mario Van Peebles is full of diverse riches from cultural and artistic experiences, travel, and two generations of a profound passion for making popular art. His father, Melvin, is a director of film, theater, and television, and an actor, composer, and writer who seemed to have fulfilled not only the mythical American dream, but to

some extent the even more elusive African American dream. Struggling persistently through barriers that would have halted many, he realized, early on, that changing his context, whether geographical or artistic, yielded tangible and long-term benefits. Donald Bogle places Melvin Van Peebles' cinematic accomplishments in this historical context: "Not since Oscar Micheaux had there been a black director as colorful and controversial as Melvin Van Peebles."[5]

Even though he graduated from college and served as a navigator in the U.S. Air Force, Van Peebles had to work on cable cars in San Francisco since he could not secure work with a commercial airline company. Later, he developed an interest in the cinema and made several short films on his way to Hollywood, but he remarked that "Hollywood had offered him two spots: elevator operator or parking lot attendant."[6] Van Peebles eventually moved to Holland and then to France where he had his first public and official sign of encouragement from the French Film Center.[7] His film *Story of a Three Day Pass* was completed and shown at the San Francisco International Film Festival (1967), and Van Peebles would go on to direct *Watermelon Man* for Columbia Pictures in 1970. The most significant turning point in his filmmaking career, however, came in 1971 with *Sweet Sweetback's Baadasssss Song*, which marked his greatest personal, social, and political accomplishment. Interestingly enough, shortly after attaining his career goals, he shifted gears, first to the theater, then to television, sustaining the diversity he had obviously become accustomed to. This provided a unique education for Mario, one that would leave him not only informed, but a hopeful and diversely talented artist as well. His father, who was an independent to the core, wanted to make films that would appeal to large numbers of African Americans. How would Mario meet the needs of a diverse contemporary Black audience on a "popular" scale?

When Mario Van Peebles pondered *New Jack City*'s social and aesthetic goals, he relied on skills from his work in television and sought to build on his father's accomplishments in the Black independent movement. More importantly, he made use of a familiar and successful Hollywood formula, the gangster film, identifying this popular genre's influence on his work. The time seemed right. There was enough promise in Hollywood to encourage his ideals, even with the long-established realities of what most recognized as a race-biased industry. If there were to be real change in the industry, though, he was prepared to play a part in the historic evolution. In an interview with Jacquie Jones, Van Peebles explained the connections and distinctions between *New Jack City* and

what he considered to be the film's predecessors: "*New Jack City* is the first gangster movie that I've ever seen where, emotionally, you applaud the villain getting his comeuppance. You don't do that in *The Godfather*; you kind of want him to live. Same thing in *Scarface*."[8]

It should come as no surprise, then, that Van Peebles used footage from *Scarface* (1983) and his father's explosive hit *Sweet Sweetback Baadasssss Song* (1971) in *New Jack City*. In this way, he revealed genre ties while encouraging the audience to draw parallels not only between these films in general, but with their central characters and themes. Viewers learned what *Scarface* and *Sweetback* meant to Mario Van Peebles, but also to the main character, Nino Brown, within the context of the film.

New Jack City is about modern-day Black gangsters in Harlem, one of New York City's predominantly Black neighborhoods. The film's version of the American dream is fulfilled through criminal activities. In the debates on the subject of Black crime, the exclusion of Blacks from economic stability in America is sometimes offered as an explanation or justification for criminal activities. While these debates can be volatile, examining the issues proves useful in reading the film's message. Essentially writes Regina Austin, "Those who identify with black male lawbreakers accept the validity of the justifications the lawbreakers offer to rationalize their behavior."[9] According to *New Jack City*'s producers, Doug McHenry and George Jackson, however, the film was not intended to glorify crime, gangsters, or drugs. It was to be a vivid and informed warning, a stylish cautionary tale about the daily devastation caused by drugs and crime in many such communities throughout this country. They explain, "Our film does not glorify drug culture, it vilifies it."[10]

The sequence under consideration is approximately forty minutes into the film. The events occur after Nino Brown (Wesley Snipes) and the cop (Ice T) who plagues him are introduced to the audience. Nino, who has been established as an unsympathetic character, and his associates have ruthless and unpopular control over the Carter apartment building, located in a Black neighborhood, and their headquarters for the production, sales, and distribution of crack. The opening shot of the sequence is an exterior shot of a darkened entrance to a house. Al Pacino's voice is heard from the film *Scarface* (1983). We cut to an interior shot of a towering film screen. In this film-within-a-film sequence, Al Pacino plays Tony Montana, who is Scarface. He is center screen, facing both audiences in a medium shot, holding a machine gun and screaming, "OK, you wanna play rough, say hello to my little friend." He fires, demolishing a

doorway, part of a wall, and toppling several men who were on the other side. While this continues, the main film's camera dollies back in the darkened room to reveal two couples, Nino and his associate Gee Money with their respective girlfriends, Selina and Uniqua. Both couples are sitting on couches, placed below the screen. For a few moments we observe them watching the film and sipping champagne. We cut back to the screen, Pacino's voice continues, and we see the continuation of the door, wall, and men falling. Nino lifts his glass proclaiming the world as his (a Montana refrain) as the *Scarface* soundtrack fades. Gee responds by asking Nino not to forget the brothers. Uniqua, Gee's girlfriend, turns, placing a hand on Nino's knee to confirm his declaration, hoping that he will not be as careless as Montana, referring, of course, to *Scarface*. Nino responds, removing her hand, letting her know that she is correct, and lets Gee know that he appreciates his girl. Uniqua then gets up and explains that she belongs to no one, and Selina, Nino's girlfriend, responds with palpable anger.

To change the subject, Uniqua turns on dance music, aggressively pointing a remote control at Selina, and then stands and begins to dance as she moves in front of the screen still playing *Scarface*. As Uniqua walks, she begins to undress. The scene continues with Nino rising from the couch to stand near her, also in front of the screen, lifting his arms again proclaiming even louder, "The world is mine, all mine." Uniqua, still next to Nino, continues dancing as the film continues, now visibly flickering on their bodies, creating the momentary illusion that both are in the *Scarface* film. Uniqua begins to seduce Nino more directly. "A man like you needs a legacy, a son, a mark to let the world know that he was here." Nino turns and chides Selina, mimicking Montana's Cuban accent, taunting her about the fact that she can't have children, a problem she shares with Montana's wife. Eventually, Selina leaves the room, and Gee chides Uniqua about her comments. She ignores him and continues dancing. The film-within-a-film then switches from *Scarface* to *Sweet Sweetback's Baadassssss Song*, where an injured Black man is seen writhing on the ground, inspecting his wounds.

How do reflexivity and intertextuality in this sequence help to validate the film's perspective and set the stage for its overall agenda? Is this the defining moment in the film's broadcast of a "message"? It is reasonable to say that these strategies do, in part, train the audience to be critical of media. We must note, however, that Van Peebles accomplishes this by using the very same medium and formula. We must also note that he pays a great deal of attention to the production details in *New Jack City*,

which contributes to the seductiveness of the illusion. In this sequence, for example, the layering of the activities and his use of colors beckons the viewer while reinforcing boundaries. In other words, he prevents the viewer from having the same success that Nino has "entering" his narrative fantasy *Scarface* through the film-within-a-film technique. What Van Peebles calls attention to and critiques is this particular form of spectatorship. This exercise, he hopes, will ensure that we understand film is fantasy or illusion. Thus, watching *New Jack City* should not produce the same results as Nino's experience with *Scarface*.

The central shot of this sequence takes place in a dimly lit room, rich with colors, and has three distinct planes. The scene vacillates between the "reality" within the film to the "illusion" of *Scarface*. For the viewer's benefit, these two illusions are meant to depict and deter. The first level, closest to the audience, is the darkest, placed at the lower left third, and inhabited by Gee and Nino's girlfriend Selina. It is significant that both of these characters are wearing black. The second, occupied by Nino, wearing a bright royal blue suit, and Uniqua, wearing red, is full of color and is in the center third of the screen. It is here that the wine and food for the evening's celebration are placed, where the film-within-the-film includes Nino and Uniqua. It is where power exists. The top third of the screen, the farthest from the audience, is where the film clips from *Scarface* and *Sweet Sweetback* flicker. This layering effect affords the audience a necessarily complex point of view. The definitive moment in the composition follows a line of sight, or thought, as the case may be, that begins with the *New Jack* spectator. The viewer is seated below the first screen, watching Gee and Selina watching Nino and Uniqua watching and moving into the second screen where the fantasy or illusion exists. It is in this moment of simultaneous "watching"—double consciousness, if you will—that we find the message and the process that contains its delivery.

Van Peebles is not at all modest about his aesthetic efforts or intentions in *New Jack City*. "When you look at the film, you've got to realize that there's a lot of production on the screen,"[11] he has said. Van Peebles' use of colors can easily be equated with the establishment of each character's mood and power in the sequence and the film at large. The selection of colors in this sequence is a vital key to reading this portion of the film text. Clearly, the dark colors for Selina and Gee versus the vibrant blue for Nino and red for Uniqua tell us much about the characters and their placement in the narrative, which, in turn, helps us to further interpret the scene.

Movement is a defining element in *New Jack City*. We enter the narrative from an aerial view in rapid motion over the port of New York. We pass quickly by the Statue of Liberty placed on the left side of the screen and move toward the lower Manhattan skyline and the World Trade Towers, also on the left. We dissolve to an overhead shot looking straight down onto the rooftops of buildings, then dissolve again to a lower angle of the New York skyline as we pass. We note, with the help of recognizable landmarks, the Pan Am, Chrysler, and Citicorp buildings, that we are in the most prosperous part of the city. The camera continues moving to the right, giving us a view of the 59th Street Bridge and part of Queens. The traffic in this shot is moving away from the city. While suspended over the river, we move in toward the action now taking place on the bridge. A man is suspended upside down by the ankles and, after a brief and volatile exchange with Nino, is released and plunges into the waters below. We return to the overhead roof shot, but we are now clearly in a less prosperous part of the city. Finally, we are placed on the ground and find ourselves in the smoldering slums, populated with the homeless and poor. We are between two Black men in the midst of a drug deal. Movement as a dominant force in the film is established early on with this pre-credit sequence and sustained throughout. The director also uses distance, direction, and symbolic places to introduce the city and its neighborhoods, and to insinuate limitations and boundaries. For example, we are always placed far away from the Statue of Liberty or the World Trade Towers, which represent prosperity, and very close to poverty, crime, and violence.

Sound plays several important roles. In every shot that composes the scene and the sequence, there is, of course, dialogue dealing with the actual events, as well as sound from the film-within-the-film, which navigates the psychological moods and fantasies of the main character, Nino. The music in the scene is controlled, and, we assume, selected by Uniqua, whom we later see seducing Nino, and speaks to her desires and intentions. These boundaries are broken, however, when Nino taunts Selina, mimicking Montana's Cuban accent. In this moment, we are cutting across the sound spheres, making closer ties with the two protagonists, from different films. For the *New Jack City* audience, this is intended to expose Nino's internal relationship to Montana's Scarface, which, until now, was based primarily on the external or visual. For the audience, the comparison is no longer optional. There was, however, for those paying close attention, a clue when Nino first used the phrase "The world is mine." Thus, Nino's placement in front of the screen with *Scarface* playing on

his form, is heightened or reinforced when he mimics Montana's Cuban accent, another key to unveiling Nino's desired existence.

Nino sees himself as a larger-than-life gangster, powerful and in control. Although he emulates Scarface, he does not want to repeat his mistakes. Uniqua obviously shares his vision. From our point of view, however, Nino has already made the same mistakes and will, as foretold by this scene, pay the same price. Gee and Selina are posited in the film as excluded observers of the fantasy and as Nino's victims. Finally, the *New Jack* audience is given a privileged perspective and armed with the ability to make a choice. We can be informed, educated, and critical observers, or willing victims of mainstream media. The sequence used here foreshadows Nino's end, but only from the audience's point of view.

Appropriately enough, the clip chosen from *Scarface* marks a point at which Montana knows that he will die, and where Sweetback is wounded and on the run. These clips leave an ominous cloud over Nino's existence. The one significant difference between the two films, is how they end. Sweetback, played by Melvin Van Peebles, is a hero. Although wounded in the clip shown, he will survive, and he has the support of the Black community. Montana may or may not have the audience's support, but Nino is completely unsympathetic. The most vital reading of this sequence, which involves the viewer, is, in fact, playing out of the message of the film. It is a warning to spectators who may harbor desires to emulate this or any film's gangsters. This notion of visually training the viewer is, in fact, a regular occurrence in the contemporary movement. We have seen the process in Marion Riggs' *Color Adjustment*, Spike Lee's *Do the Right Thing*, and Robert Townsend's *Hollywood Shuffle*. Van Peebles' choice of clips is most significant. His selection of a moment when Sweetback seems defeated and desperate, juxtaposed with Montana in his most hysterical final moments, is essential to the narrative and the message it contains. In this context, any viewer for whom Nino reads as "gangster hero" must observe Nino mimic and emulate his gangster hero, knowing that he nears the end of his self-destructive path. This carefully composed scene exposes the folly and shortsightedness of such desires. It is this simultaneous comparison that facilitates audience analysis.

Although each individual clip bears specific significance to the *New Jack City* agenda, the homage to these two films also brings forth more general genre comparisons. Brian De Palma's 1983 *Scarface* is a remake of the 1932 gangster classic of the same name, directed by Howard Hawks. This genre uses a specific recipe for success and is one of Hollywood's most durable. Although for Mario Van Peebles there proved to be obvious

connections between Nino and his formula ancestors, there would be one significant difference: Nino was not positioned as a hero. He is a villain, and not only an enemy of society in general, but specifically of the Black community. The film, without hesitation, posits Nino as an internal infection, a powerful force of evil capable of nothing but destruction. Van Peebles takes responsibility for this on two levels. As director, he cannot allow Nino to win support from the audience, and, as a law enforcement character in the film, he must prevent him from destroying the community.

De Palma's 1983 character *Scarface* is Tony Montana, a Cuban criminal who gained entrance to the United States by posing as a political refugee. Both Montana and Nino are fans of classical Hollywood cinema and both emulate their stars. When Montana is questioned by immigration officers about his English, he responds, "I watched guys like Humphrey Bogart, James Cagney. They teach me to talk, I like those guys."[12] *New Jack City*, given its agenda, could not follow the tradition of the classical American gangster film. Any identification with the gangster as hero would prove to be detrimental to the film's intended audience—Black youth. Here is Frank Krutnik's description of the genre: "The gangster-hero," he notes, "is a masculine over-achiever who triumphs in a (criminal) context where success is dependent upon nerve, quick-wittedness and brute force. At the core of such stories—which trace the gangster's rise to power, and then (briefly) his downfall and death—one can identify a violently ambitious masculine fantasy."[13]

While *New Jack City* lives up to these standards, it stays clear of the desire to make Nino a hero. Countering the formula in this way is the most important point in the film, and Van Peebles averts this easily. With great cinematic skill, he depicts the damage Nino causes to the Black community. "Nothing," writes Austin in an article in *Southern California Law Review*, "illustrates the multiple threats to the ideal of 'the black community' better than black criminal behavior and the debates it engenders."[14] Austin defines two positions in relation to Black criminal activity: One is the "politics of identification," and the other, the "politics of distinction." She continues, "The black community evaluates behavior in terms of its impact on the overall progress of the race. Black criminals are pitied, praised, protected, emulated, or embraced if their behavior has a positive impact on the social, political, and economic well-being of black communal life. Otherwise, they are criticized, ostracized, scorned, abandoned, and betrayed."[15] The film's position in relation to Nino, then, is defined by the politics of distinction. He is a problem, and any solution,

including murder, is welcome, the narrative suggests. "According to the politics of distinction, little enough attention is being paid to the law-abiding people who are the lawbreaker's victims,"[16] Austin concludes.

Not in this case, however. The hero in this film is the law, a cop from the Black community played by popular rapper Ice T. In films classic to the genre, law enforcement and criminal activities are not easily distinguishable. In many cases, the villains were wearing badges. In *New Jack City*, however, the law plays a much different role. Although its practices are questionable, law enforcement emerges as the real hero, there to protect the citizens by any means necessary. Jones, obviously displeased with this twist, explains in comparison to *Sweetback,* "Yet while the elder Van Peebles envisioned the law as necessarily an enemy of Black people, the younger positions it as a savior to Black people in communities fraught with self-imposed lawlessness (i.e., "Black on Black" crime)."[17] As Austin suggested earlier, the Black community is divided over the issues of criminal activities, and one reason might be the way Black communities are policed. She explains, "In addition, the politics of distinction encourages greater surveillance and harassment of those black citizens who are most vulnerable to unjustified interference because they resemble the lawbreakers in age, gender, and class."[18] To be sure, there are no easy answers. Law-abiding citizens in the community who are the regular victims of crime do support stronger policing, a real-life debate embedded in the fabric of this film.

As we think about the clips, we could question why Van Peebles chose the De Palma version for *New Jack City*, and not the 1932 Howard Hawks' original. Montana, in my estimation, is a more obvious outcast, and Pacino reads as a more modern icon. More importantly, this was most likely the version that influenced Mario's development as a spectator and filmmaker. In Robin Wood's view, the De Palma remake had innovations of its own. "Everything that really works in the film," he insists "is new...."[19] Melvin Van Peebles' *Sweet Sweetback's Baadasssss Song* (1971), on the other hand, was conceived and received as provocative, and revolutionary in a positive sense, although some found it objectionable. Toni Cade Bambara resists the film's position on many levels, and in relation to one particular issue writes, "In the Black community it was both hailed and denounced for its sexual rawness, its macho hero, its depiction of the community as downpressed and in need of rescue."[20] Manthia Diawara's perspective is a positive reformulation of some of the issues raised by Bambara. On one point, however, he agrees wholeheartedly: the positioning of "Black manhood at the expense of women."[21] He

defines the film in terms of its goals and the forces the film intended to resist, noting that the film "defines itself by positioning the spectator to identify with the Black male hero of the film."[22]

New Jack City ranked as one of the biggest box office hits in the contemporary period of African American cinema. While the film set something of a new standard for Blacks in Hollywood, Van Peebles was denounced for its skillful reworking and updating of the gangster genre. The film, according to *Variety*'s 1992 "All-Time Film Rental Champs,"[23] ranks as twenty-fourth on the list. At that point in the '90s, it followed James Cameron's *Terminator 2*, Jonathan Demme's *The Silence of the Lambs*, Martin Scorsese's *Cape Fear*, and one other contemporary African American film, John Singleton's *Boyz N the Hood*. Nonetheless, criticism continued. Mario and Melvin Van Peebles in different ways, and very different times, endeavored to reach the mass Black audience with a popular film. Few could deny Mario's commercial or crossover success. "So far," wrote Jones in 1991, "*New Jack City* has made over $40 million at the box office . . ."[24] Neither the film's ability to get studio support nor its record-breaking commercial success could shield it from criticism. As far as Ed Guerrero is concerned, the updating of the genre formula from a *Sweetback* perspective is not necessarily commendable. The film's positioning or repositioning of the law and law enforcement is not in keeping with the historical agenda or political posture of an African American perspective,[25] he argues.

Jones in her article, "The New Ghetto Aesthetic," also gives another searing account of *New Jack City*'s "tactics," which she claims are used to attain Hollywood prominence and success, clearly coded as a "crime" of sorts for Black people. "*New Jack City*," she insists, "is the kind of propaganda film that allows for the easy dismissal of problems ravaging the Black community."[26] Jones agrees with Guerrero's assertion that the glorification of the police in the film does not attend to the real and daily problems facing Black communities and a very problematic relationship with law enforcement. "Instead," she continues, "[*New Jack City*] emerges as a smooth new age gangster tale with little cultural reference. Ultimately, it looms as little more than a Blackface *Scarface*."[27]

It is fair to say, then, that *New Jack City*'s problems have more to do with content than with form. From an artistic perspective, this may well be a good film. However, from a political perspective, it is criticized for having a counterproductive posture for the Black community, specifically young Black males and the harsh realities they face in respect to policing. Despite the criticism about *New Jack City*'s genre roots, its commercial-

ism, or its positing of the law as a "good" solution for Black-on-Black crime, there is clear evidence that Van Peebles positioned the film between two branches of American cinema: the traditional Hollywood gangster film, represented by *Scarface*, and the Black independent cinema movement's *Sweet Sweetback*.

Since we have been discussing various readings of the film, Black spectatorship must enter our discussions. What position, whether political or social, is the audience given or encouraged to take? Spectatorship, after all, is not limited to the act of viewing taking place within the *New Jack* film text. This is not just about Nino's spectatorship; it is about the film's audience, and their political position at the moment of viewing, whether in public theaters or private living rooms. Van Peebles' intentions are clear: Make an issue of Nino's spectatorship by recognizing the influence of an alluring and seductive medium. Aware of the potential for misreading, Van Peebles, from his point of view, went to great lengths to fight against the seductive technique of celluloid. Nino might well be representative of anyone seated in the *New Jack* audience who fantasizes about gangsters or criminal activities. Van Peebles understood the challenge. "If you erred on one side," he noted, "you glorified the wrong equation."[28] I suggest, in the case of African American cinema, that there is very little distance between the intended audience for these films and the narrative space, but, according to Diawara, the topic of Black spectatorship has not been fully explored. As he sees it, Black spectatorship can be related to "resistance."[29] What he does not discuss, however—and this is necessary for a reading of *New Jack City*—is the scenario where a Black spectator identifies with a non-Black character. Nino, for example, clearly identifies himself with gangsters like Montana. Simultaneously, one hopes the *New Jack City* audience is not emulating Nino in the same way. It would, of course, be easier to identify with Nino, or put him in a similar place in their lives, since he is a Black man. If the film's goals are to be realized, however, the audience will have drawn very clear lines between what Nino is experiencing with Scarface and their own experience with Nino, the *New Jack* "gangster."

Notes

1 Richard Setlowe, "Shiftin'Gears, Movin' out of the Hood: Black Filmmakers Expanding Horizons—and Expectations," *Daily Variety,* 8 October 1993, 11.

2 Donald Bogle, *Blacks in American Film and Television* (New York: Simon & Schuster, 1988), 474.

3 Setlowe, "Shiftin' Gears," 11.

4 Jacquie Jones, "From Jump Street," *Black Film Review* 6, no. 4 (1991): 12.

5 Bogle, *Blacks in American Film and Television,* 474.

6 Ibid., 475.

7 Ibid.

8 Jones, "From Jump Street," 13.

9 Regina Austin, "The Black Community," Its Lawbreakers, and a Politics of Identification," *Southern California Law Review,* 65, no. 4 (May 1992): 1777.

10 Doug McHenry and George Jackson, "Missing the Big Picture," *New York Times,* 26 March 1991, sec. A, p. 23.

11 Jones, "From Jump Street," 14.

12 Brian De Palma, *Scarface* (1983).

13 Frank Krutnik, *In a Lonely Street: Film Noir, Genre, Masculinity* (New York: Routledge, 1991), 197.

14 Austin, "The Black Community," 1770.

15 Ibid., 1772.

16 Ibid.

17 Jacquie Jones, "The New Ghetto Aesthetic," *Wide Angle* 13, no. 3, 4 (July–October 1991): 34.

18 Austin, "The Black Community," 1773–1774.

19 Robin Wood, *Hollywood from Vietnam to Reagan* (New York: Columbia University Press, 1986), 140.

20 Toni Cade Bambara, "Reading the Signs, Empowering the Eye: *Daughters of the Dust* and the Black Independent Cinema Movement," in *Black American Cinema, ed. Manthia Diawara* (New York: Routledge, 1993), 118.

21 Manthia Diawara, "Black American Cinema: The New Realism," in *Black American Cinema* (New York: Routledge, 1993), 9.

22 Ibid.

23 Lawrence Cohn, "All-Time Film Rental Champs," *Variety,* 24, February 1992, 125.

24 Jones, "From Jump Street," 12.

25 Ed Guerrero, *Framing Blackness: The African American Image in Film* (Philadelphia: Temple University Press, 1993), 187.

26 Jones, "The New Ghetto Aesthetic," 34.

27 Ibid.

28 Jones, "From Jump Street," 13.

29 Manthia Diawara, "Black Spectatorship: Problems of Identification and Resistance," in *Black American Cinema,* ed. Manthia Diawara (New York: Routledge, 1993), 211.

Chapter Three

Boyz N the Hood

John Singleton, 1991

"You are told to believe in the system—a system that was not created to serve you and your own. Sometimes you believe in the dream; other times you catch reality."[1]

John Singleton

John Singleton's directorial debut, *Boyz N the Hood*, has an incredibly riveting and disquieting opening. On a mostly darkened screen, we see an outline of the film's title centered in the distance. It increases in size as it rockets toward the audience like the stark and colorless bars of a cage, eventually disappearing past us. This image is accompanied by explosive and violent sounds. What we hear, with no visual orientation, is an anonymous encounter that leads quickly and violently to a gunshot murder. These horrors take place in the dark, and somewhere, we assume from the language, in a Black neighborhood. The loud and emotionally overwhelming sounds, voices, gunshots, screeching cars, screams, and a police radio provide the ambience for the following statistic that appears in white letters on the black screen. "One out of every twenty-one Black American males will be murdered in their lifetime." The screams continue, and we hear the tearful voice of a young, unidentified boy desperately calling out, "They shot my brother, they shot my brother," and another fact appears before us: "Most will die at the hands of another Black male." We hear the piercing hum of a siren mixed with helicopters overhead, as well as the continuation of the sounds and voices. Suddenly, a loud singular beat introduces what could be called the first image of the narrative. We see a stop sign, center screen, in front of and slightly above two houses that occupy the bottom half of the screen, and a distant plane in the sky on the top half of the screen. The stop sign seems to divide the image into two worlds or spaces: the neighborhood below, and the sky

above, where the airplane is visible. To reinforce the importance of the stop sign, in case the audience has missed its significance, the camera zooms in until STOP fills the entire screen.

In the next shot, Tre (Cuba Gooding, Jr.), the film's main character, is introduced. We cut to him as a young boy on a street corner, standing alone under a one-way sign pointing left. "South Central Los Angeles, 1984," appears at the bottom of the screen. The camera follows him as we notice his surroundings. We are introduced to his friends and observe them in this particular morning's routine, which includes the inspection of a neighborhood street where gunshots mark the walls and blood stains the sidewalks. Thus, we begin our relationship with Tre, and for the next two hours, we will be taking the time, thanks to Singleton, to find out who he is and the conditions of his existence.

Even at this early stage in the film, the use of signs and symbols is quite noticeable. Manthia Diawara explains their relation to Black life, noting that they "play an important role in limiting the movement of people in South Central Los Angeles."[2] Singleton, however, in control of this narrative, uses the first sign (STOP), at least, in a very different way. He does not use it to stand as a representative of the limitations placed on Black life in America, as could be said about the "One Way" or "Wrong Way" signs noticeable as we met Tre on the corner in the opening sequence. He uses the familiar stop sign to visually encode the film's intended message. It is symbolic of resistance, a necessary plea to counter the horrifying statistic revealed in the previous scene. It empowers, rather than inhibits, the characters. This particular use of the stop sign in *Boyz N the Hood*, then, is not meant to represent any social action against the characters in the film. It could be argued that the film on the whole occupies this same philosophical or political space, where the familiar is used to signify resistance.

Another clue or symbol found early in the narrative is the airplane seen and heard passing overhead. We assume from Tre's reaction to the blood and bullet marks that his neighborhood witnesses this type of violence on a regular basis. While the significance of the plane is not fully realized until much later in the film, its presence does immediately imply notions of flight or escape. What we are not yet fully aware of in these first moments is flight or escape from what? Although we have superficial reasons from the compelling opening, it is not until much later in the narrative, as we observe and experience the characters' lives, that we understand the reasons for flight. In fact, we are asked by the director to live with these reasons for two hours. This is the point of the film. Soon after the open-

ing, however, and beginning immediately with the next few sequences depicting Tre's youth, we begin our journey by observing the immediate threats to his emotional and physical existence.

Singleton's *Boyz N the Hood* is a Black male coming-of-age story with an honorable and complex agenda, woven into a multifaceted story intended for Black and White audiences. The film follows a group of Black children as they pass quickly, painfully, and for the most part unsupervised, except by law enforcement and correctional institutions, from childhood to adulthood in South Central Los Angeles. The narrative centers on three male characters and those who influence their daily lives as they advance toward the brutal realities of manhood. This triumvirate includes Tre (and his separated but diligent parents) and his two buddies, Doughboy (Ice Cube) and his brother Ricky (and their mother who regularly shows her dislike for Doughboy). Unfortunately, the story moves forward because Tre's mother, Reva (Angela Bassett), is unable to raise her young son and sends him to live with his father, Furious Styles (Laurence Fishburne). This unrealistic twist did not go unnoticed by critics and cultural theorists who quickly note that the survival of Black families and communities often rests on single mothers. This particular element of the story, however, is regularly used to describe how the narrative unfolds. "Unable to control her increasingly wild son Tre, Reva Styles sends him to live with his father Furious, who can teach him to "'be a man,'"[3] Mark Kermode wrote.

We follow Tre in this new life with his father through father-son moments set in contrast to the time spent with his young friends Doughboy and Ricky. Furious constantly imparts instructions for daily as well as long-term survival, offering social critiques on the state of Black life in America. In sharp contrast, the time Tre spends with his friends expose us to the hazards of their existence. This portion of the film ends as Tre and his father return from a fishing trip to witness Doughboy's arrest. Seven years pass, and we assume that much of this time is spent educating Tre and establishing the importance of a male role model in a young man's life. The emphasis placed on the male parent, however, is at the expense of the Black woman, represented here by Tre's mother. Henry Louis Gates, Jr., acknowledges the film's merits, noting this significant flaw: "At the same time the movie resorts to stereotyping upper-middle-class black women."[4]

As was the case with *New Jack City*, this film's narrative has much to do with the daily realities of urban Black communities and Black spectatorship in relation to the media. With *Boyz N the Hood*, however, we move from the streets of New York City to a Los Angeles neighborhood

for this reality-based fiction. While many of the same issues, such as spectatorship, the politics of identification versus the politics of distinction, and so on remain, our context is a young Black boy's life, not that of a destructive Black gangster's. In this configuration, the complex formations of childhood, family, and notions of parenting can play a central role in both real and metaphorical terms.

The rest of the film follows the characters, now young men, as they continue to navigate their daily volatile existence; their group friendship has expanded to include Tre's girlfriend, Ricky's son, and Doughboy's weapon to accompany his jailhouse education. Furious continues preaching and teaching, Ricky's love of football seems to be opening doors to college, and Doughboy will remain in the 'hood. One day while returning from a neighborhood store, Ricky is killed in a drive-by shooting and the group sets out to find the culprits and avenge his senseless death. Here the line between the politics of distinction and identification are not as clear for the viewer as they were in *New Jack City*. We feel sympathetic toward these young men. We understand their situation; however, we remain sure that violent solutions to their conflicts cannot, on any level, be encouraged, supported, or excused. Violence, this film says, is not a solution to the problems of daily life. The power of the film in fact rests on this emotional motion, a swaying that one moment leans toward the politics of identification, and in the next, toward distinction. Yet, the message is clear: STOP.

The sequence selected for analysis is strategically placed at the end of the film and begins with a medium shot of Tre opening the front door of his house. He exits, closing the door, sits on the stoop, and begins to eat something from a napkin. He is distracted and looks up as we cut to a long shot of Doughboy leaving his house across the street, with a forty-ounce bottle of beer in his hand. He passes a woman with a shopping cart, then stops to greet a man on the sidewalk and makes a transaction—drugs, the audience suspects, based on what we already know about the character. He then walks toward the viewer and Tre's house, crossing the street to his destination. He sits down next to Tre on the stoop and gently reassures him. He explains that he understands why he left the car the night before. (Doughboy and his friends were on a mission to avenge Ricky's death.) Sounds of the 'hood persist: screeching cars, blaring rap music, squeaky shopping carts, a crying baby, barking dogs, sirens, and police helicopters overhead. Doughboy tells Tre he shouldn't have gone anyway, and that those things can come back to haunt him.

At this point the film slows to a solemn pace. Singleton's hope that we have not become accustomed to senseless violence, a daily occurrence in

many such communities, has for the most part come true. So while the audience may now be acclimated to the *sounds* of the 'hood, there is deeper understanding of what they mean for the residents. "Besides the gang violence and the verbal violence," notes Peter Brunette, "there is a constant psychological violence expressed most effectively in the subconsciously annoying whumpa-whumpa of unseen police helicopters that runs throughout the film."[5] For the viewer, the distance and anonymity of the opening sequence has faded. Singleton has given us faces, names, and lives to contend with. Doughboy continues explaining that he got up early and watched television, that the concern was about violence in the world, which the media only related to foreign places. Doughboy says they reported nothing about his brother, then tearfully outlines the circumstances of his existence. Tre breaks his silence and asks if they "got them." Doughboy does not answer, but Tre gets the message. Doughboy then admits, that he isn't even sure about his feelings and wonders when he might be killed. At which point, he takes a sip from the bottle and says that everyone dies but the wrong clock was punched on his brother Ricky. Doughboy gets up to leave and is stopped by Tre, who walks over to him. Standing face to face, Tre tells him that he still has a brother. Doughboy thanks him, and they hug. Doughboy then steps to the sidewalk, pours out the beer, and crosses back to his house, disappearing as he reaches his side of the street. The following appears on the screen during Doughboy's walk to the other side of the street: THE NEXT DAY DOUGHBOY SAW HIS BROTHER BURIED. TWO WEEKS LATER HE WAS MURDERED.

Given the film's opening statistics and the difficult but informative time spent with the characters, Doughboy's statement about the media at the end is tragic in a double sense. On one hand, there is the tragedy of murders occurring daily in Black communities. We spend almost two hours understanding those realities; we see a dramatization of the opening statistics. On the other hand, according to the film and numerous real-life accounts, no one cares, which we understand from Doughboy's perspective. Violence then, in Doughboy's neighborhood, is not a "problem" for anyone outside the community, or even expressed as a concern on a national level. Doughboy's critique of the media was well constructed and strategically placed. It bears great significance that these words, this acknowledgment and disclosure, resonate from the tragic hero and not any other character. If, for example, the commentary came from the responsible Furious or an incidental social critic, such as the old man in *New Jack City*, it would not hold the same significance or, more importantly, speak to the same audience.

It is also significant that the television news item Doughboy refers to is not shown. Singleton's skillful use of "omissions" should be noted, particularly in this case but, more importantly, in Doughboy's death. These points, Singleton suggests, are better made without visual confirmation. So, ironically, in these final moments, the violence that drives the narrative exists offscreen. Thus, the deliberate "omission" of the news segment further reinforces the point. This is a fact of life for Blacks in America, and television media, says Singleton, has to take ownership of its practices. His film notes that these practices have been recognized, acknowledged, and critiqued, not to mention countered, by many artistic and political acts, including this film, *Boyz N the Hood*. It should be noted that Singleton does, when he deems it necessary, find use for the television in several scenes; however, he places it exclusively at the disposal of the characters. Doughboy and his friends, for example, use it to play video games, and Ricky employs its technology to replay one of his football games to impress a recruiter from USC. Perhaps these scenes merely illustrate how media should be used. Perhaps they illustrate what is "seen" rather than what is not, confronting issues of representation in mass media.

The fact that Singleton placed this critique at the end of the story stands as testimony to his skill in effectively presenting the issues. Doughboy makes this statement to Tre, a potential survivor, and incidentally to the viewers. He wants to pass on what he has learned, needless to say, the hard way. As social commentary, it would not, by any stretch of the imagination, have been as successful at any other point in the film. This moment, well placed at the end, is left to linger like a eulogy. Doughboy's words make clear the perspective Blacks have on the American media and its attitude toward the problems of the Black community. His disclosure takes place after the audience has had an extended opportunity to witness and potentially grasp what, in Doughboy's words, is "goin' on in the 'hood." The presentation of this perspective, the understanding that Black Americans, even so-called criminals, are well aware of the fact is one of the subtler yet more powerful points of the story.

The film's primary cultural, social, and political message is made clear in the opening sequence from the juxtaposition of written text and the stop sign. This technique is extremely effective, as we have discussed in relation to Marlon Riggs' *Color Adjustment*, where the strength of a message lies in its context. Mere words in the abstract, but what do they mean? Black-on-Black violence. Black-on-Black crime. Stop. *Boyz N the Hood* makes a valiant attempt to inform and engage us in the meaning of

these words. Of course, the film and its director insist that the violence must stop, but there are many other agendas at work, including crossover, television media, and issues of stereotyping and exclusion. For everyone—Singleton, Doughboy, even learned scholars—the problem of stereotyping or representation, or in this particular case, exclusion, is of major concern. Clearly, the film speaks to the members of the Black community, in particular, young Black males, but it also converses with the larger American society.

Most of the time, *Boyz N the Hood* maintains its double-sided intentions. The lessons within the narrative are intended not only for the characters in the film, but for its diverse audience. Tre is representative of the few who will survive this and many other such tragic real-life tales. As a survivor, the individual lessons learned here must also belong to the community depicted in the film as well as to Black communities in general. Like *New Jack City*, this film depicts most profoundly the dangers from within the boundaries of the community. For the viewing audience, the learning process is varied, even difficult, yet arguably offers a privileged perspective. The opportunity to teach others abounds in contemporary African American cinema, often through moments such as these.

Doughboy's critique of American media is certainly not indicative of a new position or revelation on the subject. What is new is where this version of the critique comes from. While omission from mainstream media touches the lives of many nonwhite Americans, critiques are usually found in newspaper articles or scholarly works. It is certainly not expected from a young criminal in the 'hood. The difference is that Doughboy's message about the priorities of mainstream media will reach more people than any formal academic critique. That is, in fact, one of the goals of African American cinema—to speak directly to and for the people negatively affected by the dominant media. In contemporary African American cinema, the increase in eloquent and hard-hitting disclosures that Blacks in America are very much aware of their treatment by American media, whether by marginalization, stereotyping, tokenism, or exclusion, is evident. Todd McCarthy, in a review of *Boyz N the Hood*, also outlines how the film presents the media, noting its "tendency to treat ghetto crime as a mere fact of life that doesn't need to be invested with the same seriousness as events in the white world or even overseas."[6] African American cinema's depiction of Black communal life and Black spectatorship must regularly present critiques of mainstream media. That this is usually accomplished through an intertextual or reflexive moment, occurring at some particular point in each film's overall theme,

is essential to note. This persistent fact about media and its relationship to nonwhite citizens is cinematically navigated or countered with these political and aesthetic tools. Contemporary African American cinema then, among its other agendas, questions the history, focus, and priorities of the dominant media in this country.

Embedded in Doughboy's disclosure is a profound and well-expressed sense of abandonment and powerlessness. He is aware of his exclusion. This powerlessness, according to the narrative, is meant to characterize his personal state but also the state of his community. That it also reflects the relationship many Blacks have in relation to the media is a commentary on the state of the country's overall attitude toward people of color. African American cinema attends to Blacks and their ability to influence the media's direction and priorities. While Singleton exerts control over the fictional world presented in the film, most Blacks are powerless on a mass scale. The localized power that exists for a small number of Blacks is depicted as, and is limited to, the playing of video games as witnessed in *Boyz N the Hood* and *Clockers*. Other examples include the replaying of personal homemade videos, or surveillance tapes, in both *Boyz* and *Menace II Society* or Hollywood films as seen in *New Jack City, Juice,* and *Menace II Society*. Blacks in America simply do not have the power to make or distribute mass media.

Leaving the arena of omissions for a moment, let us examine how Blacks are represented when they are "included" in the film and television media. We have explored in a previous chapter, with Diawara's help, one version of tokenism. Media stereotypes are a liability for all the groups draped in its ill-fitting, uncomfortable, and often dangerous cloak, but for African Americans, males in particular, the price appears to be the highest. Many African Americans, including Singleton, keep a watchful eye on American media. Here he expresses real-life observations and concerns in relation to the media coverage of the Rodney King videotape (which appears in the opening of Spike Lee's *Malcolm X*): "Most of the coverage was centered on making this an African-American issue, when in truth there were people of all ethnic backgrounds who protested and later looted and vandalized property."[7] Because of the power of the media, films and television in particular, media has become a more public and commercially viable tool or voice for a few Black Americans. African American cinema, with its political and aesthetic agendas, can be used as a response mechanism to disenfranchisement, powerlessness, and exclusion. The genre stands in opposition to the ideologies and priorities of the dominant media by giving a platform to the concerns of Black life in

America. Black life, Black desire, Black memory, Black fantasy, and Black criticism now have their place. *Boyz N the Hood* makes its comments on the media with profound clarity. It speaks to a contemporary awareness. (We should note that we discuss this now when audiences are very much "tuned in" to the problem of representation in the media.) What we are examining here is how Black life is depicted and prioritized by a contemporary group of African American directors.

The purpose of our analysis of *Boyz N the Hood* is to focus more attention on African American cinema's perspective of the relationship Black life has with mainstream media. Specifically, we see how film and television media relates, or does not relate, to the daily realities of Blacks in America. This film, as well as several others in contemporary African American cinema, intends to expose and simultaneously counter the priorities of American media. Black-conceived and directed media, then, stands in opposition to what the mass media considers important. It counters notions of established truths and deals with representation. It also deals with issues from groups that are excluded and, more importantly, questions the process that selects representatives. We are not simply noting that the image of Blacks often depicted on television reinforces the stereotypical opinions held by the larger society. Essentially, *Boyz*, through Doughboy's life and final statement, is making another point: that the media does not care for or about Black people, Black males in particular, the way it cares about other citizens.

In order to achieve this goal, the film must also contend with notions of realism while confronting issues of representation. Doughboy is a criminal. Indeed, he is a gangster, but he is not at all similar to any of the characters in *New Jack City*. The question here is, Can we empathize while knowing the awful truth about him? Does his life have any value? Can we learn anything from him? According to the gangster formula, we can. What, then, is the specific nature of our politics (distinction vs. identification) in relation to Doughboy? In our exploration of the gangster formula undertaken in the previous chapter, we discussed several significant points about the genre and can assert that Doughboy does represent the tragic hero.

While the main element, the identification with the gangster as hero was in contrast to *New Jack City*'s agenda, it is an essential element in *Boyz N the Hood*. Singleton enlists this particular element of the formula, purposely avoided by Van Peebles, to get the film's message across. What Doughboy expresses in his statement about television is profound, "deep," and, by this time in our relationship with the characters, well

understood. He is, like the rest of us, deeply disappointed. Doughboy is not, as the media or any "stereotypical" approach would have it, violently angry about the treatment of his brother's death, his life, or his community. For McCarthy, "Treatment of the subject here underlines the fact that all such incidents are horrifying and tragic, with family and community consequences that need to be more deeply understood and felt by the nation."[8]

So our hero has many tasks: protecting his brother Ricky and his friend Tre; surviving in the 'hood; and, last but not least, educating the audience. In experiencing and examining *Boyz N the Hood*, we can better understand Doughboy's final conversation with his only friend. It is clear that Singleton uses Doughboy, as well as Furious, to educate Tre. They are both responsible for making sure he knows "how it really is" in society as well as in the 'hood. For Diawara, this film is a coming-of-age story where the process of passing from youth to adulthood involves a family member or friend "who teaches him, or helps him to overcome the obstacle. At the end he removes the danger, and his nation (or community, or family) gets stronger with him."[9] Tre is spared or saved when Doughboy allows him to leave the car the night Ricky's death is avenged. It is clear, at least to this observer, that the greater sacrifice has been made by his friend and "brother," Doughboy, and not his father.

In what can only be called a strange twist of fate, *Boyz N the Hood* and its director, Singleton, would play a major role in the media eruption that occurred around the Rodney King videotape and its life in the mass media. Los Angeles, through these real-life events as well as the subsequent trial and verdict, finally found itself in a desperate quest to understand what happened and why. Not surprisingly, they turned to the film and its director for some answers. Singleton, an obvious choice because of his film, was asked by *Premiere* magazine to write an article on the verdict in its July 1992 issue. One of the more telling comments, related to the theme of this work, is the relationship he draws between African American films and the events that transpired in relation to Rodney King. "Anyone," he insists, "who has a moderate knowledge of African American culture knows this was foretold in a thousand rap songs and more than a few Black films."[10] It should be noted that when this anger or violence is directed at the community, not much is done to protect its citizens; however, when it spills beyond the borders into mainstream society, swift action is taken.

As is the case with many African American films, a strong connection was made with *Boyz N the Hood* and the actual and very real events transpiring in society, specifically in South Central Los Angeles. The film's

location in American social, political, and cinematic history was, in fact, fixed, infused into the real-life events surrounding the Rodney King videotape. Ed Guerrero explains: "Responding to escalating tensions, California Governor Pete Wilson came to appreciate the film's social importance and felt compelled to recommend that all citizens see *Boyz N the Hood*."[11] Many of the topics in contemporary African American cinema by now have been woven into political and social debates taking place in American society. Debates about crime, poverty, multiculturalism, and family values have merged with issues pertaining to race, gender, and class. For African American cinema, it is natural to touch on all of these themes in the context of Black life. These concerns are often reflected through the failings of our society, and in such cases, the political is as important as the aesthetic.

Self-representation is a perfect example, a theoretical vehicle for these issues and debates, not only in the politics surrounding the funding and making of African American films, but embedded in the individual themes. In the larger society, the debates taking place about self-representation, interestingly enough, further complicate the issue of representation, even for African American filmmakers within the Black community. Black Americans, marginalized in society as well as in Hollywood films, are now able, to a degree, to speak for themselves, prioritize their own issues, present their own point of view on American society, offer a different version of history, and, above all, perpetuate their own images.

But things are far more complicated. A perfect example of this is the debate surrounding Lee's biography of Malcolm X (1992). Was Lee the right person, or the best person, to direct the film, simply because he was Black? Not necessarily, as Guerrero points out: "In August '91, the black writer and critic Amiri Baraka declared at a Harlem rally of the United Front to Preserve the Legacy of Malcolm X, 'We will not let Malcolm X's life be trashed to make middle-class Negroes sleep easier.'"[12] Baraka was not the only one to challenge Lee. Many came forward to question the film's perspective.

With any genre of filmmaking, particularly African American cinema, the narrative connection to "reality" can and often does present artistic and political limitations. For example, *New Jack City*'s skillful cinematic depiction of violence was frequently, at least by the media, made inseparable from and at times responsible for the real-life violence that occurred in many of the theaters where the film was being shown. With *Boyz N the Hood*, however, the connection to "reality" proved to be beneficial, or at least not as damning as was the case with *New Jack City*. The claims of "real," again connected to violence, produced obvious and substantial

merits for the filmmaker and further enabled the connection with viewers. For the intended audience, African American males, realism was the key to commanding their attention, a validating element that permitted the director to deliver his message.

There are, as expected, understandable, and unresolved, concerns surrounding the question, What is real? It is of particular importance when ascertaining the authenticity of the messenger, in this case the director of a film. It is of the utmost importance when making judgments about African American stories and who is qualified to make these decisions or, in other words, to be our guide. Sometimes, these questions are as vital as the films themselves. How do directors achieve realism in fiction films that proclaim a task of representing reality? One way that does not further complicate the naturalistic process is to make good use of intertextual and reflexive moments. We all know that realism intended is quite different from realism as received, as we have experienced with our analysis of *New Jack City*. Film audiences, no matter what the director's agenda or success in attaining "reality," are left to make up their own minds. Final authorship of the film is the purview of viewer. What is clear is that *Boyz N the Hood* worked on many levels. The film still stands as a representative of the best the genre can offer.

African American cinema endeavors to exist within and simultaneously outside the context of American mainstream cinema. The genre does so in a self-conscious manner. In each individual case, whether the film is successful or not, the issues speak to the fact that the director was first trained as a frustrated spectator. Any film and its author present a personal and singular perspective, no matter how universal the theme or familiar the formula. How the perspective is constructed, and whether or not it is understood, has very much to do with the factors explored in Chapter One related to spectatorship. The viewer's race, age, gender, political orientation, economic status, and social class are all factors in his or her reception of the information. The topic of all films classified as African American are complex and charged, often volatile, with palpable, textual, intertextual, as well as real-life meaning. Navigating racial issues and, more importantly, crossover and intraracial issues, particularly in the context of violence, drugs, poverty, and crime, has never been easy. Spectatorship of cinema that depicts real-life events can be in many ways as turbulent as the events they represent.

Within the genre, films noticeably take different approaches to content depending, of course, on the director's position as a spectator. These films are informed by various production styles. Black independent filmmaking and Hollywood formulas and styles factor most into the develop-

ment of each director's individual aesthetics; in other words, they help develop form, not content. Depending on the theme, however, there is the risk that a chosen formula may not be celebrated, as we have seen with *New Jack City*. Within African American cinema, distinctions need to be made in each approach. This arduous task is also paramount for any and all explorations of the genre. The differences, as well as the similarities, must be explored. They have to be understood. If we omit this vital step, we sabotage our quest to understand not only the origins but the inventiveness of African American cinema as well. Clyde Taylor makes some of this clear when he writes, "*Boyz N the Hood* and *Juice* aim to speak with some honesty to the abject mental vacuum that leads young Black men to slaughter one another, arguably one of the most difficult problems for any Black speakers or leaders, let alone filmmakers."[13]

What can directors, of any color, do if they want to reach a large portion of the mass audience? Should African American directors, given the country's political and cinematic history, steer completely clear of Hollywood formulas and styles? Are there other options? And if so, what are they? "A movie that breaks with too many existing movie codes," Taylor writes, "will lose its audience. The parameters in which movies like *Boyz N the Hood* and *Juice* get made to reach young Black moviegoers with a popular spectacle means making compromises that a critic ought to consider."[14]

Boyz N the Hood has had a profound impact on the lives of the very people it was supposed to represent. Audiences in general have been engaged, "getting" their own profound message from the film. That the film was so deeply rooted in the "realities" of this country supports the real-life importance and potential of such works of art. According to Peter Brunette, "Singleton says that *Boyz* allows them to 'see themselves on film and they can reflect upon it. Think about their situation and the situation of their friends and family'."[15] Singleton's use of media in *Boyz N the Hood* is strategic. The manner, style, choice of character for delivery of the message, and placement in the narrative structure proved to be quite effective. The film makes a critical point for the national context of Black-on-Black crime. It is also intended to highlight the connection, or lack thereof, that Black Americans have to the larger American media. Doughboy's perspective about media, as it is placed in the narrative structure, primarily reinforces the senselessness of the destruction of Black American males. It also makes it clear that not enough attention is being paid to these events and the larger issues they raise. *Boyz N the Hood* highlights the point, reinforcing and maintaining the sense of the double tragedy.

Notes

1 John Singleton, "The Fire This Time," *Premiere* (July 1992): 75.

2 Manthia Diawara, "Black American Cinema: The New Realism," in *Black American Cinema*, ed. Manthia Diawara (New York: Routledge, 1993), 22.

3 Mark Kermode, "Reviews: Boyz N the Hood," *Sight and Sound* (November 1991): 37.

4 Henry Louis Gates, Jr., "Must Buppiehood Cost Homeboy His Soul?" *New York Times*, 1 March 1992, sec H, p. 11.

5 Peter Brunette, "Singleton's Street Noises," *Sight and Sound* (August 1991): 13.

6 Todd McCarthy, "Boyz N the Hood," *Variety* 20 May 1991, 39.

7 Singleton, "The Fire This Time," 75.

8 McCarthy, "Boyz N the Hood," 39.

9 Diawara, "Black American Cinema: The New Realism," 20.

10 Singleton, "The Fire This Time," 75.

11 Ed Guerrero, *Framing Blackness: The African American Image in Film* (Philadelphia: Temple University Press, 1993), 186.

12 Ibid., 198.

13 Clyde Taylor, "The Positive Void," *Black Film Review* 7, no. 2 (1992): 22.

14 Ibid.

15 Brunette, "Singleton's Street Noises," 13.

Chapter Four

Juice

Ernest Dickerson, 1992

"The bad news comes from real life. *Juice* is only the messenger."[1]

Janet Maslin

By 1992 it was obvious that Hollywood studios were paying more atten-
tion to Black directors. It was now time to see if the excitement about
works produced in 1991 had permanently set African American cinema
on a more consistent path. Industry attention was of course motivated by
financial need and was not necessarily in support of the social or political
goals of African American cinema. Nonetheless, Black Americans were
pleased, for the moment at least, to see more of their stories in the main-
stream media. The still new contemporary period of African American
cinema was not just gaining momentum with commercial studios and
mainstream audiences, it was sustaining it. This new and energetic breed
of American filmmakers were young, well educated academically, cin-
ematically, and politically, and had made a significant place for their work
in the larger culture. They were engaging a broad range of American
audiences while speaking to contemporary African American issues di-
rectly. These filmmakers were viewed as rebels with an important cause.

By this time, it was clear that they were speaking to and for a section
of the population that had no social, economic, or political voice. Bring-
ing their version of contemporary Black life to the screen was the number
one priority on the agenda. Given the increasing popularity of the genre
and the obvious financial rewards, Hollywood studios could not find Black
filmmakers fast enough. Finally, the industry's "something new, some-
thing fresh" mantra was yielding results.

For some of the participants of the Black independent movement who
began in the early 1980s, new opportunities were available with increased
possibility of support from major Hollywood studios. Although money

was not flowing, more resources went to Black films, but in smaller amounts than for White directors. Most of the money, however, went to the Black males from the earlier movement, leaving African American females in much the same situation as before. We will be discussing this further in the next chapter. Did Black directors have to make significant compromises in the move from independent to mainstream? What, as Marlon Riggs asks in *Color Adjustment*, was the price of the ticket?

Mark Reid discusses some of the benefits he feels encouraged African American filmmakers to abandon the independent mode of production: "Regardless of these artistic and financial limitations," he insists, "many blacks will seize any opportunity to work for a major motion picture studio because studio films receive company sponsored distribution and marketing as well as a guaranteed production budget."[2] One of the more detrimental limitations of independent filmmaking, for example, is publicity. By the time an independent low-budget or no-budget film is completed, most of the funds for the project have likely been used, leaving little for the expensive and necessary advertising required for securing an audience for the film. Thus, as Reid notes, a critical benefit of studio sponsorship is the sizable "P & A" (publicity and advertising)[3] budget available in concert with a wide and efficient distribution network. Thus, for both sides, there are tangible benefits.

Juice (1992) is Ernest Dickerson's debut film. His previous commercial work was as cinematographer on several Spike Lee films, notably *Do the Right Thing* (1989) and *Malcolm X* (1992). His directorial addition to the genre was a New York-based tale of four Black urban youth: Bishop (Tupac Shakur), Quincy, or "Q" (Omar Epps), Raheem (Khalil Kain), and Steel (Jermaine Hopkins). The film rivaled *Boyz N the Hood* in theme, but according to critics, little else. Dickerson takes us on a dark and relentlessly grim journey through their volatile and rapidly disintegrating teen friendships which takes a fatal turn when Bishop's uncontrollable rage transforms him into a ruthless killer. *Juice* represents another Black male coming-of-age story, and the statistics remain overwhelmingly grim. Sadly, unlike *Boyz,* the film does not facilitate a meaningful relationship with any of the four main characters or expose any benefits to their association as a group. It is difficult to accept, for example, that Q's friends do not support his career-launching DJ competition. Instead, they encourage him to miss the event and accompany them to a neighborhood robbery. As was the case with *Boyz N the Hood*, we discover the personal and intimate details of young Black men killing each other in America today. *Juice*, which focuses primarily on the violence, reaches further

depths in the tragedy of senseless murders, which resides with the fact that the young men killing each other are close friends.

The film begins with each of the main characters waking up and getting dressed for school, which they never attend in the film. Q, Steel, Bishop, and Raheem all live with families who seem to care about them, or so we assume in the brief time we are permitted to observe their interactions. They meet for school, but instead go to a neighborhood hangout, equipped with pool tables and video games. As the cops arrive, they escape, except for Steel, who is brought to the police station. Later that day, they meet again and pass their school time roaming the streets, scaring a White pedestrian, and stealing records. Eventually, they get hungry and make plans to raid Steel's refrigerator. En route, Q is sent into a bar to get cigarettes and meets Blizzard, an old neighborhood friend just released from prison. Blizzard informs Q that he is going to rob the bar and offers him "a piece of the action." Q refuses, returns to his friends, and notifies them of the offer. They decline, except for Bishop, who clearly wants to get involved. The others manage to convince Bishop to leave, and they continue on to Steel's house, where they watch television while Steel prepares breakfast.

It is at this point in the story that we encounter our media moment. We enter the scene, observing Steel in the kitchen alone, stirring a strange mixture of meat and eggs. An establishing shot of the living room informs us of each character's placement. Q is nearest the audience, dancing about in a chair with headphones on, completely involved in his own world of music. Raheem is seated right on the couch and Bishop is on the left, and they are both watching the television. Bishop is clearly more involved with the images on the screen, which we note by his body language as the film plays. A close-up of the television reveals Cody Jarrett (James Cagney) from the film *White Heat* (1949). He is in a rage, screaming and pounding on a table in the dining hall of a prison. Quickly, he gets up and starts flailing around, making moaning sounds, screaming, and striking at everyone within arm's reach. The camera moves to Bishop who throws a punch mirroring the emotionally distraught gangster, saying: "Bust 'em, POW!" while jumping off his seat with each exclamation. To further depict his excitement, the director sustains the moment as Bishop engages Raheem and gives him "five." In a reverse angle of the living room, we see Steel entering with plates in hand.

We move back to the television, where the film still plays, to a close-up of Cody's wife as she tells her lover, Big Ed that she did it, for him. Cut to a close-up of Big Ed removing a cigarette from his mouth, informing her

that Cody will be angry to hear that she was shot in the back, referring to the manner in which Cody's mother was killed. Cut to a close-up of Bishop surprised, repeating that they shot her in the back. Cut to a medium close-up of Q shouting to Steel about borrowing something, referring to the music playing on his headphones. As Q establishes and reinforces himself as non-participant in the celebration of *White Heat*, Bishop angrily leans over, removes one of the earphones, and says to Q, "Excuse me," then tells him that he should be watching TV. To show his anger, he lets the earphone go and it slams into Q's head. Q gives him the finger and, for the first time in the film, we begin to notice a pattern. Q is interested in his music and Bishop is interested in crime and violence, whether real or fictional. We then cut back to the film, where we see Cody in an industrial plant firing at the machinery causing an explosion and fire. During the blaze, the police retreat as Cody stands erect and screams, with Bishop in concert, "Top of the world!"

We return to Bishop as he bounces in his seat screaming, alone this time, "Top of the world," with intense and obvious excitement. His emotional involvement with the film is clear from his excited physical state. He stands up, as we cut to a medium shot of the television. "The End" appears on the screen, and Bishop reaches across this final image, lowers the volume and tells the group, if you have to die, that's how you should go! He continues, noting that Cody took his destiny into his own hands. Cut to Steel who questions that kind of destiny through a mouth full of food. Bishop goes over to him and asks what he controls, to which Steel responds that he controls his own life. Bishop disagrees and informs him that he has more control over his life than he does. Steel inquires how and Bishop reports that he is letting him breathe. At this point, Bishop's unjustified rage is noticeable in dramatic contrast to Steel's playful nature. Steel reminds him that he can't even walk on his own block. "It's Blizzard!" someone shouts, and Bishop turns up the volume on the television as they listen to the news of Blizzard's failed robbery and death. Bishop, increasingly upset and enraged, argues with his friends about the state of their lives and makes it clear that he admires Blizzard. We note his consistent admiration of criminals, now related to Blizzard's appearance on the news as well as Cagney in *White Heat*. Finally, the growing conflict between Bishop and Q culminates in a fight. Eventually Raheem steps in and forces them to make peace, which they do, but the tension is still visible.

The plot proceeds with the robbery scheduled for the night Q performs in the DJ competition. This takes a fatal turn when Bishop, for no

plausible reason, decides to kill the store owner. The group decides to discard the gun, but Bishop refuses, and in a struggle kills Raheem. The two remaining friends separate, in obvious distress about Raheem's death and fearful of Bishop and what he might do next. Q finally confronts Bishop, who makes some grim and hopeless facts known to his friend and the audience. He declares that he *is* crazy and that he does not care about anyone, including himself. He ends by telling them that he is nothing, and, finally, that he is the one they need to be afraid of. Bishop eventually shoots Steel and the film ends with the final battle between Bishop and Q, where Bishop accidentally falls off a building.

What was Dickerson's motivation in making *Juice*? Where is his message? He explains his intentions revealing how the story came about in an interview with Jacquie Jones: "It really came out of wanting to tell a story about growing up today; it grew out of seeing what was going on in our neighborhoods."[4] Dickerson held on to the script for eight years, until he sensed that the time was right for the film. As is the case for many African American directors who rely on the gangster genre, he had serious and valid concerns about which character the audience, particularly young Black males, would identify with. Which identity politics would engage this group of viewers? He explains his hopes and intentions: "I was really worried that a lot of the young kids would end up identifying more with Bishop. I wanted kids to identify with Q."[5] *Boyz N the Hood* dealt more extensively with family interactions, but *Juice* stays primarily with the four young men who are the focus of this dark and gruesome tale. While this is an understandable stance for the filmmaker, we must question its effectiveness. Was this in fact detrimental to the film's message? Dickerson explains his decision: "I specifically set it within the boys' own world without any real interference from parents or older people because it is about the dynamics within a peer group."[6] Jones sees merits in Dickerson's intentions and describes the texture and value of this context: "Together the characters explode the veneers of camaraderie and macho, often taken for granted in cinematic rendering of young Black men. And though the film has been criticized as needlessly violent and nonredemptive, it offers a moving portrait of one boy's attempt to purge his community."[7]

According to Jones then, focusing the audience's attention almost exclusively on these four does not limit the variety of perspectives surrounding the events in the film. Each of the four has a different social and political position or conviction about the state of their lives. Each of them interacts differently to issues of representation, crime, media, and the world around them. Bishop clearly exhibits a politics of identification with

lawbreakers as witnessed in his desire to accompany Blizzard to the rob-
bery and, of course, as he watches *White Heat*. The others exhibit vari-
ous forms of the politics of distinction. Michael Dyson perceives the dif-
ferences in this way: "Of all the crew," he notes, "leader Raheem, a teen
father, GQ, a DJ with ambitions to refine his craft, and Steel, a likable
youth who is most noticeably the 'follower'—Bishop is the one who wants
to take them to the next level, to make them like the hardcore gangsters
he watches on television."[8] Is this mix successful enough to deliver the
film's message? We may agree that Bishop's character is reprehensible
enough to repel most viewers, but does Q represent a strong or devel-
oped force of resistance? In other words, does he survive because of his
convictions or is he simply saved by his ambivalence? The narrative sug-
gests that he is strong enough, since he expresses his resistance to Blizzard's
invitation and convinces the group to leave a potential crime scene earlier
in the film. He is interested in advancing himself in music and not crime.
While he pays no attention to *White Heat* or Bishop's gangster rituals
around the film, he does weaken at a pivotal moment in the film when he
leaves the DJ competition to accompany his friends to the robbery.

The sequences from *White Heat* used in *Juice*, much like our other
media moments, navigate the lives of African American males as well as
their role as spectators. Unlike *Boyz N the Hood* but similar to *New Jack
City*, *Juice* affords viewers the opportunity to watch one of the film's
characters watching his fictional gangster idol. Dickerson, however, uses
the added element of a television news report about Blizzard's death to
further make his point about Bishop's identification with lawbreakers. We
are privileged with the insight provided by observing the character in
relation to two forms of media. In other words, through observing Bishop's
politics of identification with both real and fictional gangsters in the me-
dia, a politics of distinction is encouraged in the audience. Thus, intertextual
or reflexive moments serve two functions: first, to reinforce the origin of
form, and second, to solidify the meaning of content. Robert Sklar deals
with form here, reinforcing the relationship between classical Hollywood
cinema and African American cinema: "The violence and sexism of black
male youths in these films were indeed as vivid and controversial as simi-
lar behavior of Irish or Italian mobsters portrayed by Cagney, Robinson
and Muni decades earlier."[9]

White Heat (1949), directed by Raoul Walsh, is about a tiny but turbu-
lent gangster named Cody Jarrett (James Cagney). Although Cody, like
Bishop, is part of a team, he is clearly *not* a team player. The only one
Cody trusts is his mother, and for good reason. Bishop trusts no one, not

even himself. Cody is regarded as a "crackpot," an identity established early in the film with the help of his associate and rival, Big Ed. We are encouraged by Walsh, however, to develop a sympathetic attitude toward Cody. Shortly after the opening sequence where a train robbery takes place, Cody is stricken with a severe headache and is comforted, we note, by his mother and not his wife. He describes his pain as "like having a red-hot buzz saw inside my head." As Cody's mother follows him into a private room, we witness his childlike qualities hidden beneath the rough gangster exterior. When he decides to leave the room and return to the group, his mother insists that he remain until the pain passes but, soon after, pushes him to go and show the others that he's OK. Before sending him off, however, she hands him a drink, offering a toast, "Top of the world, son," a phrase that will evolve into a battle cry, in both *White Heat* and *Juice*.

Dickerson's selection of *White Heat* to contextualize Bishop's character is a perfect choice, according to Frank Krutnik's assessment of Cagney's role. "In each film, James Cagney plays an old-style gangster figure whose energy and ambition have transmuted into psychosis,"[10] Krutnik writes. In *White Heat*, Cody ends up in jail after confessing to a lesser crime. In order to obtain evidence for the real robbery, an undercover policeman is sent to prison with Cody to get information. While Cody is in jail, his wife and partner Big Ed turn against him and arrange for an "accident."

Undercover policeman Hank Fallon saves Cody, and that same day, Cody's mother visits him to reveal the plan to end his life and her plan to avenge the betrayers, his wife and Big Ed. This news gives Cody another headache, and he is aided again by Hank. This solidifies the bond between Hank and Cody, and together they plan an escape. While still in prison, Cody is informed of his mother's death. He becomes violent in the dining hall and is hospitalized in a straitjacket. Eventually, with Hank's help, he escapes and avenges her death by killing Big Ed. Shortly after, Cody is set up by Hank and meets his death in the fiery blaze seen in the clip at Steel's house. Krutnik contextualizes Cody's end: "Jarrett fires into a gasometer upon which he has taken refuge, and in a destructive, psychotic apotheosis he proclaims the sheer power of his deviance, as he shouts triumphantly: 'top of the world, ma!' (this self-willed destruction of the world—identified by Freud as a common paranoid delusion—serves as an ironic allusion to the 'The World is Yours' sign which in *Scarface* (1932) crystallizes Tony Camonte's drive for success)."[11] While Bishop and Cody have similarities, there is one difference. Although both can be classified as criminals, Cody gains our sympathy because of the physical

pain he suffers, but primarily through the betrayals he suffers. Bishop, however, has no excuses for his behavior.

Although Dickerson's narrative does not blame anyone in particular for Bishop's instability, he does offer hints to his psychological state. Are the depicted circumstances of his life valid reasons for his behavior? Looking deeper into Bishop's psychological state, one could contextualize him in a different way. Judging from Bishop's comments shortly after *White Heat*, we could rely on notions of victimization, powerlessness, and hopelessness as root causes. Soon after the group hears of Blizzard's death, Bishop makes a heated speech to the others cataloging the people they run from on a regular basis. Bishop says he feels like he is on a track team. After the exchange of harsh words, Q finally asks why they were fighting.

Bishop's emotional pain, along with Q's question, fit Frantz Fanon's description of the "settler-native" relationship described in *The Wretched of the Earth*: "While the settler or the policeman has the right the live-long day to strike the native, to insult him and to make him crawl to them, you will see the native reaching for his knife at the slightest hostile or aggressive glance cast on him by another native; for the last resort of the native is to defend his personality vis-a-vis his brother."[12] Regina Austin also makes the connection between urban violence and Fanon's work. She centers in on how a "community of victims" is created when a people are not apprised of their history, how this leads to an inability to control destiny, and that such a community victimizes itself. "Unfortunately," she notes, "Fanon's insights are rarely invoked in analyses of contemporary black urban violence."[13] Bishop clearly feels constricted by his environment and powerless because of the state of his life. Unfortunately, he reacts by turning against his friends. Austin gives an account of lawless behavior that fits Bishop's situation perfectly, confirming this behavior as a social phenomenon. "These young people's lawless resistance also misfires because more often than not their targets are similarly situated minority folks,"[14] she writes. Fanon's map can be used as a guide to understanding this contemporary predicament. It offers an important context for Black-on-Black crime. While colonialism is not at work in the streets of Black communities today, the realities of poverty and policing in the post-slavery era mimic its oppressive structure.

After hearing about Blizzard's death, Bishop becomes visibly distressed and pensive. He reveres Blizzard now as he did Cagney minutes before. There is one important difference between the two: Blizzard is a Black man and a member of the community, and Cody is a fictional Hollywood character. Bishop begins an explanation of his theory by outlining the

state of the lives of young Black males, and claims with great fervor that one has to be ready to die like Blizzard to get respect and "Juice"—street language for power. It is at this moment that it becomes clear that he has replaced Cagney's fictional character Cody with Blizzard. Instead of identifying with a fictional Hollywood lawbreaker, who happens incidentally to be White, he can now identify with someone of his own class, race, and age.

For Dyson, however, the interpretation of the scene is markedly different. He reads Bishop's actions as indicative of the fact that he has emotionally combined Cody and Blizzard into a single type, a composite that is to be respected and emulated. "Viewing Cagney's famed ending in *White Heat*, and a news bulletin announcing the death of an acquaintance as he attempted armed robbery, Bishop rises to proclaim Cagney's and their friends' oneness, lauding the commendable bravado in taking their own fate into their own hands and remaking the world on their own terms."[15] I would maintain, however, that the sequence of the images delineates the character types and that the type of media that represents each is significantly different. *White Heat* is a dated black-and-white fiction film, and the other, a present-day news broadcast. While they both have significance to Bishop within the film *Juice*, Dickerson intends a different reading for the audience. If this were not the case, either reference would have been sufficient to make the point. The organization of the sequence is also informative. It begins with the fictional *White Heat* and ends with the real news broadcast. To state the obvious, the media moves from fantasy to the reality of everyday life.

Since there were now enough African American films in the period between 1986–1992 to classify the nature and direction of the genre, discussions of a comparative nature ensued with great vigor. Essentially, films and their directors were placed in competition not only in financial terms, but political and aesthetic terms as well. Negative criticism increased, based on the chosen mode of production, independent versus commercial. Traditional Hollywood styles and formulas, the Blaxploitation era, and the Black independent film movement all served as historical springboards for these critiques, depending on the politics of participants and the nature of the debate. Contemporary Black filmmakers, like those before them, were facing harsh critiques from within the Black community. Heated statements about positive images began to change the nature of these debates, which turned into an overall critique of the new Black urban film genre. This put an inordinate amount of pressure on Black directors. Were critics or audiences in favor of "positive" images

completely missing the point of these films? Was creating a cinema of good intention the only charge for contemporary Black directors?

From box office history, there was clear indication that the Black audience, not unlike mainstream audiences, supported blockbusters and frequented gangster and action films. Finally, Ed Guerrero tells it like it is, making a clear point, not only on behalf of *Juice*, but for all films in the genre dealing with the realities of Black urban life and adjacent issues: "As painful as it might seem to some," he insists, "*Juice*'s overriding insight does not concern redemption."[16]

Since many of these films tackle the most difficult social issues of our time, they naturally go far beyond the goals of cinema of good intentions. Crime, racism, and violence, to name a few, are not subjects that can, if explored honestly, be easily transformed into positive messages, nor does realism equal negative representation. Cinema in general faces these same issues, but the priorities of African American cinema are, necessarily, far more complex. One of the best texts for exploring notions of "positive" images of Blacks on television is Riggs' *Color Adjustment* (1991). His movement between familiar media images, written text, and historical footage asserts the difficulties and dangers in fixing positions, whether positive or negative. More significantly, it explores the limitations in so-called positive images. For African American directors, the preoccupation with positive images serves no real social, political, or aesthetic purpose. Adherence to such ideals would place their work in much the same space as the films they endeavor to counter. So-called positive films could either repeat often stereotypical media reports or offer the standard unrealistic Black characters seen regularly in mainstream films. They would offer nothing that transcended existing representations or enabled further insights. In other words, they would not mediate race, class, or culture. Clearly, there is a profound sense of fear at work in this debate, a fear that believes that directors engaged in depicting the realities faced by today's Black urban youth do little more than compose and deliver their characters as stereotypical or "negative." If this is so, is it a case of the messenger taking the blame?

The African American community is not a homogeneous community. Differences and tensions in the community are often elided for fear of airing dirty laundry and perpetuating a public intellectual conflict that mimics Black-on-Black crime. This leaves many with the impression that Blacks move as a political mass, having one opinion, when the truth is quite the opposite. Black Americans, it is true, are very watchful of the activities of prominent and public representatives of the group. Henry

Louis Gates, Jr., offers a historical perspective on this matter: "For as we know, the history of African-Americans is marked by its noble demands for political tolerance from the larger society, but also by its paradoxical tendency to censure its own."[17]

One can imagine the pressures imposed on, and felt by, contemporary Black artists, filmmakers in particular. Dickerson's directorial debut *Juice* (1992) presents, yes, another view of Black male urban life. It attempts to deal with the most pressing problems facing the youth in Black communities. It is safe to state, judging from the critics and box office receipts, that at this time in the evolution of the contemporary African American film genre, audiences had seen enough Black urban films and had heard enough explanations to accompany media reports about Black neighborhoods. Unfortunately for Dickerson, audiences had become less welcoming to ghetto tales, Black intellectuals and critics had taken a stand, and *Juice* had to pay the price. The public wanted to know why these were the only Black-centered stories to reach the commercial mainstream. Why is Black life, as Gates questioned earlier, restricted to the streets of urban centers? Social historians were also ascertaining what this kind of public art would bring to the daily struggles facing the Black community. Critics and spectators alike were clearly concerned and watched the genre closely.

The accusations were that the supporters of contemporary African American cinema, Hollywood studios, had an unhealthy preoccupation with Black violence, much like the mainstream news media. This was becoming increasingly hard to deny. Jones contends that "the industry's wholesale investment in films that explore only ghettoes and male youth ignores the existence of a Black community beyond these narrow confines...."[18] These were turbulent times for Black filmmakers in the Hollywood mainstream. Emphasis was soon placed on the "true" independent filmmakers, celebrating their goals as uncompromised, and their aspirations as honorable. Contemporary African American films seeking mass audience appeal and crossover status were seen by many as exploitative, stereotypical, and narrow in their vision. Thus, the African American film genre was divided into subgenres, pitting one group against the other. There was a division quickly developing, much like the differences described in Austin's politics of identification and the politics of distinction, which give greater social value to one over the other, not recognizing each for their individual contributions. "Resisting the pull of Hollywoodism," notes Lett Proctor, "Dash's *Daughters of the Dust* and Harris' *Chameleon Street* defeat the requirement to function as cultural reactionarism, insisting on the exigency for collective memory and self-actualization, the

authenticity of allegiance and frustration."[19] Believe it or not, Spike Lee joined the chorus by 1993 after the release of *Juice* and the Hughes Brothers' *Menace II Society*. Here is his call for a wider range of representation of the African American community: "There are so many great stories to tell in our history. It's a shame that now that we're finally getting a chance to do something with film, we're not taking full advantage."[20] According to Lee, "A New Wave might not necessarily be a good wave. The young African American filmmakers really have to try to get out of this hiphop, urban drama, ghetto film."[21] Finally, Lee's demand for change names individual films.[22] He lists films that he feels exist only in the service of the "ghetto" and not the Black community at large.

Nevertheless, *Juice* has presented us with an opportunity to further explore African American cinema and its self-proclaimed connection to Hollywood, specifically, the gangster film genre. It also engages the viewer in a training process, one that insists that we develop critical skills in our consumption of media, especially the representations of Black men. It attends to the impact these issues have on the community. The exclusive attention paid to the point of view of the four main characters in *Juice* continues the exploration of the politics of identification vis-à-vis a relation to criminal activities. That these intertextual scenes exist primarily for this purpose, to fix the overall position of the film, is indeed one of the points of this work. We have been enlisted to observe how they develop a point of view and note whether the process engages identification or distinction. What is of the utmost importance is this politics and how it affects the character's personal life as well as the community.

On closer examination of the film, that is, beneath the violence, we note that Bishop is posited as a character in search of "self" in both public and private terms. As he struggles to understand and contend with the doubleness of his existence, he has to reconcile the fact that he is viewed as a dangerous "other," marked early on in the film when the White man veers off when he sees this group on the street. The other side of this doubleness is how he sees himself, or how he would like to be perceived. Although he appears and is proven unstable, he manages to explain, in great emotional detail, the state of his life. His desire to take control, or as he puts it, to "get the juice" (power and respect), is not unrealistic, until it is grounded in the images of Cagney and Blizzard on television. This quest, this act of searching for self-respect, becomes negative only when he openly takes direction from fictional gangsters represented in media images and turns against his friends. This, of course, does not speak well for the influences from his community or family. It is in this respect that

the film is posited as failing to live up to or build on the efforts and success of *Boyz N the Hood*. We have seen now in three cases—*New Jack City*, *Boyz N the Hood*, and *Juice*—that there are severe problems facing Black youth throughout the country. While crime may, on the surface, present opportunities not afforded by society, these "opportunities" destroy lives, families, and communities and, according to these films, is fatal to the perpetrator.

For *Juice,* "realism," which translates as violence, is both a reality in the communities represented and a concern when advertising and distributing the films. This violence, and the debate surrounding its causes, has evolved into a permanent liability for the filmmakers. For some audiences, although cautioned against the lure of the gangster lifestyle as the media depicts it, the line between the film's message and its portrayal of violence can easily be blurred. When such violent incidents occur in or near theaters where any one of these films play, mainstream media takes the opportunity to promote its connection to the "reality" depicted in the film. What the media in fact uses as evidence, ironically, is similar to what we have already discussed when examining spectatorship and intertextual moments in each film. In a strange twist, the influence they outline is derived from the same equation set in motion by the clips from *Scarface* or *White Heat*. In other words, members of the audience identify with the Black gangster in the films in the same way that Nino Brown identifies with Scarface, and Bishop with Cody.

Andrea King, in *The Hollywood Reporter*, makes note of film-related violence as an increasing trend in African American cinema: "Of late, however, some of those films, including most recently Paramount's "Juice," have had incidents of violence and killing surrounding their openings."[23] *Juice*, as early as the poster distribution phase, it seems, was a cause for concern. In yet another *Reporter* article, we encounter more details: "As Paramount Pictures prepares to unleash its urban actioner "Juice" next Friday, rival studio executives, marketers and a Los Angeles Police Department gang officer are taking issue with the studio's ad efforts, calling the print and trailer campaign "irresponsible" and "exploitative," particularly in light of the violence surrounding the release of both "Boyz N the Hood" and "New Jack City."[24] In the end, because of the intense social and political pressure, Paramount replaced the original poster, where a gun was visible, with a gunless version.

The violence surrounding *Juice*'s opening did not help its case in the media. The film did, however, make significant political and aesthetic contributions to African American cinema, even though its timing de-

prived it of higher status in the genre. Following blockbusters like *New Jack City* and the internationally celebrated *Boyz N the Hood* proved to be detrimental. By this time in the evolution of the genre, debates about "positive images" and urban ghetto violence were in full swing. African American films were accused of taking one direction, which, according to critics, was harmful to the community. It was, of course, noted that this theme was encouraged, supported, and celebrated by Hollywood for its market appeal. Dickerson's masterful images, in this climate, were viewed as doing nothing more than reinforcing media stereotypes of Black male youth and furthering violence. This film was not widely celebrated for its accuracy in depicting the reality of contemporary Black youth.

Although we have established that positive images do little for the process of social exchange, it is also a proven fact—and, sadly, the proof comes from audiences—that positive images do not sell movie tickets. This is not confined to contemporary audiences alone. Gates confirms that "movies about the black middle class have often had trouble finding an audience."[25] Fortunately, however, for those craving diversity of theme, there are films like Julie Dash's *Daughters of the Dust*, Charles Burnett's *To Sleep with Anger*, and Riggs' work, just to name a few. If these superficial critiques of the genre are from a position that fears only what others think, we will never be able to attend to the underrepresented or the misrepresented. What point of view should contemporary African American cinema now take, and who should decide? That the genre must occupy a variety of social and political positions is, of course, important. However, if audiences do not occupy the same range, why should popular Black filmmakers take the blame? The films discussed here focus on the most destructive problems strangling Black communities across the country. Isn't that the point?

Notes

1 Janet Maslin, "Making a Movie Take the Rap for the Violence That It Attracts," *New York Times,* 22 January 1992, sec. C, p. 13.

2 Mark A. Reid, *Redefining Black Film* (Berkeley: University of California Press, 1993), 125.

3 Ibid.

4 Jacquie Jones, "Peer Pressure," *Black Film Review* 7, no. 2 (1992): 25.

5 Ibid., 26.

6 Ibid., 25.

7 Ibid.

8 Michael Dyson, "Out of the Ghetto," *Sight and Sound* (October 1992): 21.

9 Robert Sklar, *Movie-Made America: A Cultural History of American Movies* (New York: Vintage, 1994), 349.

10 Frank Krutnik, *In a Lonely Street: Film Noir, Genre, Masculinity* (New York: Routledge, 1991), 200.

11 Ibid.

12 Frantz Fanon, *The Wretched of the Earth* (New York: Grove Press, 1963), 54.

13 Regina Austin, "The Black Community" Its Lawbreakers, and a Politics of Identification," *Southern California Law Review,* no. 4 (May 1992): 1782.

14 Ibid., 1781

15 Dyson, "Out of the Ghetto," 21.

16 Ed Guerrero, *Framing Blackness: The African American Image in Film* (Philadelphia: Temple University Press, 1993), 188.

17 Henry Louis Gates, Jr., "Looking for Modernism," in *Black America Cinema,* ed. Manthia Diawara (New York: Routledge, 1993), 200.

18 Jacquie Jones, "The New Ghetto Aesthetic," *Wide Angle* 13, no. 3, 4 (July–October 1991): 43.

19 Lett Proctor, "A Rage in Hollywood," *Black Film Review* 6, no. 4 (1991): 9.

20 Richard Setlowe, "Shiftin' Gears, Movin' out of the Hood: Black Filmakers Expanding Horizons—and Expectations," *Daily Variety,* 8 October 1993, 12.

21 Ibid.

22 Ibid.

23 Andrea King, "Black Filmmakers Blast Media," *Hollywood Reporter,* 21 February 1992, 6.

24 Anita Busch and Andrea King, "Paramount Marketing Plan for 'Juice' Comes under Fire," *Hollywood Reporter,* 10 January 1992, 1.

25 Henry Louis Gates, Jr., "Must Buppiehood Cost Homeboy His Soul?" *New York Times*, 1 March 1992, sec. H, p. 11.

Chapter Five

Just Another Girl on the I.R.T.

Leslie Harris, 1993

"When thinking about black female spectators, I remember being punished as a child for staring, for those hard and intense direct looks children would give grown-ups, looks that were seen as confrontational, as gestures of resistance, challenges to authority."[1]

bell hooks

The criticism about the movement's themes continued, although 1993 would see the commercial release of the third film directed by an African American woman. Unfortunately, the overall status of Black women, either as strong central characters or directors in African American cinema, was not greatly improved. The 1990s remained a time of public scrutiny. Everyone seemed watchful of how African Americans, their communal lives, and individual priorities were represented. Even more concern was focused on who had been selected or elected as spokesperson. The appetite for Black-directed and Black-centered images would not, at this stage of the movement, overshadow the urgent need for overall diversity. The claims of "real" were no longer enough to satisfy cultural, political, and artistic needs. Ironically, some of the critical postures and debates previously constructed to police mainstream Hollywood images were now used to critique African American directors and their films.

During this time, Hollywood trade papers tried desperately to promote statistics that in their estimation pointed to increasing numbers of Black filmmakers. This suggested that African Americans were taking charge and representing themselves on the big screen. One such proclamation appeared in a 1991 *Variety* article titled "Blacks Taking the Helm," which compared the new boom to the Blaxploitation era and noted a significant change. "While those earlier actioners featured black actors and were targeted to blacks, these new pics are largely the product

of black filmmakers—and many are expected to attract white audiences."[2] Included in the article was a list of thirty-seven films that *Variety* called "Top Films by Black Directors." All the directors highlighted were male: Sidney Poitier, Eddie Murphy, Robert Townsend, Oz Scott, Spike Lee, Reggie Hudlin, Michael Schultz, Richard Pryor, Stan Lathan, Gordon Parks, Sr., Berry Gordy, Prince, Keenen I. Wayans, Ossie Davis, Melvin Van Peebles, Jamaa Fanaka, and Gordon Parks, Jr. The article continued, listing the new releases expected for later on in 1991, which included the following directors: Mario Van Peebles, Charles Lane, John Singleton, Charles Burnett, Wendell Harris, Matty Rich, and, finally, Julie Dash.

In reality, there was no shortage of Black women directors, but where were their films in the contemporary period of African American cinema now securing mainstream status? Since disclosures about the infrequent appearance of women directors were now taking shape and appearing with greater regularity in mass media, they were increasingly difficult to ignore. What about the Black independent movement that launched so many of the named male directors? Could it not lay claim to as many talented Black women? Mass media, however, was concerned only with celebrating mainstream status with their statistics. According to *Glamour*, "In 1991, nineteen feature films were released by black filmmakers, more in one year than in the last decade. But not one of those movies was made by a woman."[3]

Audiences, by this time, had become used to seeing films about Black people. Since the late 1980s, Blacks were appearing with more frequency in the mainstream. Even diversity, it seemed, was readily available. Films such as Marlon Riggs' *Tongues Untied* (1989), Charles Burnett's *To Sleep with Anger* (1990), the Hudlin Brothers' *House Party* (1990), Julie Dash's *Daughters of the Dust* (1991), Michael Schultz's *Livin' Large!* (1991), Robert Townsend's *The Five Heartbeats* (1991), and Bill Duke's *Deep Cover* (1992) provided variety for interested audiences. It would be another year's wait, not until 1993, before the next African American woman would arrive on the commercial scene as director, with a Black woman's story. The *New York Times* announced Leslie Harris' *Just Another Girl on the I.R.T.* as a momentous occasion.[4]

Bestowed with the status of "first" is Dash's *Daughters of the Dust*, which was a long time in the making. When the film was finally distributed to audiences, it was a welcomed change for the movement and, for the most part, was considered a critical hit. On the surface, *Daughters* appears to be about a Black family involved in a historic event, a partial migration from the Sea Islands north to the U.S. mainland. As Dash's

story unfolds, however, we are introduced to Nana Peazant, the family matriarch, her granddaughter, an unborn child who explains her parents and their "problem," Viola and her friend, the photographer Mr. Snead, Yellow Mary and her companion, and Bilal Mohammed, praying in Arabic. The story immediately goes beyond expected parameters. What *Daughters of the Dust* depicts, acknowledges, and supports is not only a way to ensure the preservation of the Peazant family, threatened by separation and internal conflicts, but of Blacks in the United States as well. It accomplishes this by offering an inclusive view of race, family, and culture, one that is formed in the new spaces and places created by Dash in the film.

Manthia Diawara describes the cultural value of such spaces: "In other words, spatial narration is a filmmaking of cultural restoration, a way for Black filmmakers to reconstruct Black history and to posit specific ways of being Black Americans in the United States."[5] *Daughters of the Dust* remained an impressive contrast to the dominant themes. It offered viewers a new cultural context for Blacks in film. For contemporary audiences used to the enclosed and restrictive urban spaces that set the stage for many films, *Daughters* was a breath of fresh air.

There are three significant ways in which Dash constructs these new spaces and places. The first is the story, which places the narrative focus on several main characters, six of them women. The second is the unique and effective aesthetic that grows from the number of main characters, their cultural, racial, and ethnic diversity. The third and final factor is the actual construction of the film. As we follow the flow of the narrative, we are encouraged, by the style and cinematic elements, to gather and experience impressions and not simply look for exposition or information. As viewers, we are forced to do this from a position somewhere "in between." We are placed in the story between land and sea, languages, religions, and cultures; between how women face issues differently from men; and between the past, present, and future of the Peazant family. The film's aesthetic style is accomplished by tailoring the usual elements orchestrated to compose a film's look and feel. Some of the goals of *Daughters* were also revealed in the pacing, the multidirectional focus of the story, the placement and movement of the camera, the dissolves, instead of quick edits, dollies, and pans, as well as in the accompanying timeless music.

Sheila Rule's *New York Times* article chronicles the difficulties Dash had completing the film, as well as its reception: "Ms Dash, who wrote, produced and directed the film in a 10-year labor of love, is delighted that

audiences are responding to it in just the way she hoped they would."[6] The details of Dash's difficulties speak to her dedication to the project, and we have to marvel at the fact that this film was completed at all. Rule goes on to explain her greatest obstacle: "Hollywood producers and distributors said there was no market or audience for a film they considered inaccessible, and financing was scarce."[7] For Dash, there was clearly no point in eliding the fact that the climate for Black women directors was not as favorable as for Black males. Black women were not telling the kind of stories Hollywood thought would engage mainstream audiences in a significant or profitable way. "Black women," she said, "have been out working and making films for many many years, I know at least 25 of them."[8] Among the twenty-five names that Dash lists are Neema Barnett, Camille Billops, Ayoka Chenzira, Kathleen Collins, Zeinabu Davis, Cheryl Dunye, Deresha Kyi, and Jacqueline Shearer.[9] Including Dash, these women have over forty films to their credit.

After Harris' *Just Another Girl on the I.R.T.* was Darnell Martin's *I Like It Like That* (1994), the first studio-funded film directed by an African American woman. The first African American male to direct a Hollywood studio picture was Gordon Parks, Sr., with *The Learning Tree* (1969), some twenty-five years earlier. According to Donald Bogle, "*Newsweek* saluted Gordon Parks, Sr., as 'the first Negro ever to produce and direct a movie for a major American studio.' And so he was."[10]

Understandably, the various classifications of "first" are confusing for viewers. When a film appears in the mainstream, the assumption is that Hollywood has funded the project. Sometimes, however, the confusion is due in part to the industry's desire to proclaim a "first," which it did in at least three of these cases, which means the public had to listen closely to discern what "first" they were witnessing. Another telling look at the situation facing African American women in the Hollywood mainstream comes from Amy Taubin in an article titled "Girl N the Hood," appearing around the time of the release of Harris' film. Taubin articulates the realities of Black female directors in Hollywood, highlighting, once again, the obvious and, for some, the awful truth. What Taubin touches on is important, because it points not only to the composition of Hollywood's new membership, but also its recruitment and admissions policies. She explains, "Obviously the gender imbalance (Dash did receive a passing mention in the article) was a result not of a lack of talent, skill or drive on the part of African-American women, but rather of the structure of the film industry and its perceptions about film audiences."[11] In other words, Black women directors are not afforded the same opportunities that Black males are

because the decision makers are not yet convinced that female-oriented or -directed films will sell to large audiences. Dash was aware of this diagnosis, frequently offered by industry executives, that reflected their general perspective on what mainstream audiences would and would not pay to see. "That's partly because many studio executives look down on audiences: If something is unusual, they say, 'the public won't understand this.'"[12] Nevertheless, Dash was clear about what she had to offer and realistic about how different an experience her film was for most audiences. She said, "In my film, I'm asking the audience to sit down for two hours and listen to what black women are talking about."[13] Taubin puts her finger on a particular industry perspective, and formulates at least one reason for Hollywood's last-minute support of Harris' film *Just Another Girl on the I.R.T.* She noted "that the hunt was on for an African American woman director who could deliver the goods to a popular film audience ..."[14]

The task of creating meaningful Black women on the screen, to be sure, must not be exclusively reserved for African American women. What is necessary is that these perspectives occur more regularly in mainstream and independent films, regardless of the director's sex, race, or ethnicity. We have certainly seen this attempted before, on behalf of Black women, in films like John Stahl's *Imitation of Life* (1934), Elia Kazan's *Pinky* (1949), Ossie Davis' *Black Girl* (1972), Berry Gordon's *Mahogany* (1975), Steven Spielberg's *The Color Purple* (1985), and Spike Lee's *She's Gotta Have It* (1986). This would also happen again later in the decade with Lee's *Crooklyn* (1994), F. Gary Gray's *Set It Off* (1996), and Forest Whitaker's *Waiting to Exhale* (1997).

Taubin's phrase "Girl N the Hood" might well capture the spirit of Harris' debut film, *Just Another Girl on the I.R.T.* (1993). The film's main character, Chantel (Ariyan Johnson), is a fiercely independent and irreverent Black woman, who is smart enough, or so she thinks, to make it out of the 'hood and into medical school. Harris spends little time making the character likable or her life overly sentimental or heroic. Neither the girl-in-the-'hood qualities nor its attention to realism, however, gave *Just Another Girl* the kind of attention expected, given its theme and timing. Ed Guerrero explains its status in relation to its male counterparts, noting that it "did modestly well at the box office and went into the comparable obscurity of 'film society' screenings and the shelf in the video store."[15]

Our media-related event in *Just Another Girl on the I.R.T.* takes place immediately. As it was with *Boyz*, the event is in the context of television

media and is described but not shown. The reflexive moment focuses our attention on the media issues facing Blacks and is intended to affect our examination of, and relationship to, the entire film, its main character, Chantel, and the events that transpire. The film opens with an image of a neighborhood at night. The camera pans from left to right, from a darkened (except for a light in the doorway), three-story house to the street. An energetic young woman's voice is heard whispering as a young Black man wearing a baseball cap is walking toward the camera. He is walking cautiously down the street, carrying a large black garbage bag. Although it is difficult for the viewers to see clearly, we eventually notice that he is moving toward a garbage can and several other large black garbage bags on the sidewalk, looking nervously behind, wiping his face as if removing tears. In a point-of-view shot, the camera, angled down in a medium close-up, observes him placing the bag on the sidewalk next to the other garbage bags. The young woman's voice is heard throughout this scene, explaining that what we are about to see is the "real deal." She suggests that we might read about this incident in the newspapers, or see it on television, and assume the worst about her neighborhood. What the audience is unaware of at this point is that this is in fact a scene from the end of the film. The point of the story is to let viewers know, firsthand and not through media accounts, how we arrived at this moment.

Immediately after she stops talking to the viewers, heavy beat rap music begins, and we cut to a black screen with the following, placed center in yellow letters: "Truth 24 F.P.S. presents." We then move to a long shot angled upward, where we see of a set of buildings. The camera pans down from the buildings and, abruptly, in mid-pan, as the audience follows intently, we cut to a park with children playing. With another quick cut, the camera moves to an establishing shot of a street with a one-way sign on a lamppost. The camera moves from right to left, following the direction of the one-way sign, as if in a moving vehicle traveling on the road. We then cut to a medium long shot of a young woman walking away from the camera down the street, as the female rapper continues.

The young woman is wearing a dark skirt, a light green T-shirt, and a colorful, floppy hat, and is carrying a knapsack on her back. She is walking briskly and seems full of energy, confidence, and optimism, and swings her arms, which reveals her youth. The camera cuts to a black screen with the following: "A Leslie Harris Film." We cut back to the young woman and follow her as she enters the area of the token booth in a medium shot, which the audience experiences through the surrounding thick black bars. The camera cuts to a medium close-up, as she buys a token and

playfully observes a passerby. She enters the subway platform, which is outside, and we see for the first time a sign pinpointing her location. The name of the station, like the street name near the one-way sign in the previous shot, is Park Place. The large black-and-white subway sign is layered with colorful graffiti. The subsequent establishing shot explores the surrounding neighborhood visible from the elevated subway platform. While the young woman waits outside for the train, we cut to the film's title, "*Just Another Girl on the I.R.T.*" in yellow script.

The camera cuts to a medium close-up, a two-shot showing a handsome young Black man screen left, asking the young woman, placed screen right, what her name is. She tells him that her name is Chantel. They begin to talk, or flirt, as the credits continue. We then observe Chantel on the train, riding past several outdoor stops on her way to Manhattan (evident from the signs). At 72nd Street, indicated by a similar subway sign (this time without graffiti) Chantel emerges. Several similar establishing shots show the change in neighborhood. As she observes and marvels at a large architectural structure, as if it were her first time there, the final credits appear: "Written and Directed by Leslie Harris."

The audience continues to follow Chantel down the street (she is now walking toward the camera). She has an exchange with a Black man and turns the corner, passing the camera. She continues walking, now with her back to the camera, and we follow her along, and shortly before entering a store, she stops and turns to face the audience. In a medium close-up, chewing gum, with her hands on her hips, she reports that she is a Brooklyn girl and that people think that Brooklyn girls are tough. She then folds her hands, smiles, and admits that this is true, then, with a sway in her neck, gesticulating with her right hand, she informs us that she does what she wants, when she wants, and lets no one bother her. She then turns and enters the store, and so begins our relationship with the sassy-but-smart Chantel. During this entire sequence, the strong beats and powerful voice of a female rapper dominate and give energy to the film's already quick pace.

Essentially the rest of the film follows Chantel on the subway to work, school, and home, observing her interactions with those around her. It is clear that her perception of herself is not confirmed in the reactions toward her, nor is it reflected in the media as she states at the very beginning of the film. She has an obvious problem with authority figures, and, while she is less resistant with her girlfriends, she still maintains her self-confident edge. Eventually, Chantel meets a young man and gets pregnant. She becomes very confused and is thrown almost completely off her

original path. Her boyfriend, visibly angry at her situation, secures money for an abortion, which Chantel spends in a shopping spree with her best friend. One night, some months later, she goes into labor, and after a terrifying scene, delivers the baby in her boyfriend's apartment. She convinces him to take the baby and put it on the street. Here the story completes the circle, and we find ourselves returning to the scene that opened the film.

Despite its edgy, in-your-face qualities, Harris' directorial debut, *Just Another Girl on the I.R.T.*, was not well received, and played to relatively mixed reviews. Her problems may have, in fact, started with high hopes that the film would be regarded and received as the female version of any one of the Black male urban dramas of the late 1980s and 1990s. From Taubin's point of view, evident in the title of her article "Girl N the Hood," it is clear that Harris' film would indeed be compared with the now dominant forces and trends in the genre. Taubin, however, would not be the only one to use this comparison to *Boyz N the Hood* or to make significant note of its use. Greg Tate, in his *Village Voice* article, "Flygirl on Film," would make his own statements comparing it to *Boyz*, suggesting, finally, that the analogy may be a bit overused. "Harris will probably have to endure *Girlz N the Hood* taglines ad nauseam from reviewers, but this rites of passage essay slices through the meat of easy teen sexploitation to get at the marrow of teenage ignorance, shame, and confusion about contraception, STDs, abortion rights, and parenting,"[16] he writes. *Boyz N the Hood* would not be the only film *Just Another Girl* would be compared with. Todd McCarthy adds his preference to the list: "More upscale specialty house audiences could be lured in some numbers with a "female 'She's Gotta Have It'" pitch, but pic's quality is nowhere near that level, setting real limits on b.o. potential."[17] Much of the attention would be quite negative, particularly in relation to Chantel and her irreverent and unsympathetic qualities as the main character. Ironically, some critics would respond to Chantel in much the same way her parents or school officials do in the film, or as she predicted in relation to the media in the opening sequence.

By far the most negative review came from Terrence Rafferty in the *New Yorker*, a review that Taubin described as "vitriolic."[18] While Rafferty may have had some helpful critiques, his malicious tone negated his comments, dissolving his points into nothing more than a well-publicized snit. It is not an easy task for this writer to recount his words here, but I will so that you can see for yourself the hyperbolic nature of his comments. They expose resentment toward Chantel's character and, of course, to Harris as well.

Rafferty begins his assault by giving the ninety-six–minute film, only three minutes of value. Coincidentally, his attack begins by highlighting and complimenting the media segment under examination here. "For maybe the first three minutes of 'Just Another Girl on the I.R.T.,' you feel the thrill of anticipation, a sense that you're about to get an entirely fresh perspective on the sort of black experience that's usually seen through the distorting lens of hysterical local-news reports and lurid cop movies, or merely glimpsed from the windows of an elevated train."[19] Although Chantel is by no means constructed as a "lovable" character, Rafferty is unable to detect any value in her subversiveness, any point to her resistant or insistent nature. In other words, he was unable to read any of Harris' intent with the character. He is not able, within the context of the story, to perceive or forgive any of the follies of her youth or tolerate her confidence, which admittedly reads often as arrogance. He continues: "And Ariyan Johnson's performance, which has the look-at-me enthusiasm of an obnoxious musical-comedy juvenile, marks all the most obvious formulations with garish emphasis."[20]

Harris was always clear about her goals for Chantel, and more patient and informed critics were able to detect her intentions. Julie Phillips in her article "Growing Up Black and Female" lets Harris speak for herself: "This is just a portrait of one young woman, and I didn't want her character to speak for everybody. But at the same time, I think she has a right to be who she is."[21] It is painfully clear that Rafferty is not simply misreading Chantel, but judging and dismissing her, an attitude the character is quite familiar with in the context of the film. Finally, after he disables Chantel's merits, he moves on to attack the director's abilities, negating even his earlier comments about her editing skills. "The movie would have less trouble persuading us that this brash, self-absorbed young woman dreamed of making her mark in law, politics, or the media. Harris is in such a hurry to get through the lesson plan that she garbles messages that shouldn't be difficult to put across clearly and forcefully."[22]

Joining in the assault a few weeks later was David Denby, who makes his own contributions, if we dare call them that. He offers no useful critical arguments or points stemming from his observation of the film or any understanding of the genre and its intent. One has to wonder if he saw the film at all. "Harris from the evidence of *Just Another Girl on the I.R.T.* doesn't have a clue,"[23] he writes. Fortunately for Harris, for future audiences of the film, and for students of the cinema in search of useful information about *Just Another Girl*, there is Taubin's work. Without it, the task of this chapter in many ways would have been sabotaged, since one

of the keys to understanding the impact of African American films in the mainstream is to gather mainstream reactions. Taubin provides an appropriate and reasonable response not only to the film, but to this well-publicized assault on Harris as well: "The reaction to Chantel as a character suggests the kind of unconscious racism that refuses to acknowledge that a girl from the hood could be intelligent, ambitious and vulnerable, let alone intelligent, ambitious, and vulnerable, and, though painfully confused, capable of saving her life."[24]

It has been mentioned on more than one occasion that this film resembles Lee's *She's Gotta Have It*. It should be noted, however, that in Lee's film, the main female character, Nola Darling, did little talking about her life or herself. She was, for the most part, the subject of male desire, confusion, and finally frustration. Nola Darling, even in name, can be easily posited as a man's creation or fantasy. Would she really call herself that? Jacquie Jones, in her essay "The Construction of Black Sexuality," says that Nola, "who was widely hailed as a liberated, postmodern Black woman, was only allowed to be viewed through the attitudes of the three clearly deficient men—a narcissist, a dullard and a social retard—who ultimately define her existence."[25]

Chantel, on the other hand, is, with all her faults, her own person and, thanks to Harris, is quite willing to take responsibility for herself and her actions, a novel concept in contemporary African American cinema. Harris gives her character many opportunities not only to speak regularly in the film, but to speak to us directly about the issues that challenge and concern her. These issues, although ranging across the span of her life's dreams and activities, relate primarily to the difference between how she sees herself, who she really is, and how she is observed by others, including, and most especially, the media. And, from the negative reactions to her character, she was right on all counts.

Just Another Girl on the I.R.T. is about Chantel, from her point of view, whether we as viewers like her or not. That this is her point of view is evident from her direct address to the audience. We are given an opportunity to spend time with her through the most difficult period in her life, an unwanted teenage pregnancy that threatens her dreams and her future. We live with her through confusion and decisions about how to handle her situation. That she represents many other teens in the same position is significant, whether or not we understand or agree with her choices. Tate gives an efficient description of Chantel and Harris' intentions with her as a character: "She is both stereotype and antistereotype. Though she resides in the projects, she works hard (at school and after

school—her parents hold down steady jobs); though we meet her as a flirt, she's still a virgin. Later we learn that this hiphop baby knows more about Mother Africa than she does about her own reproductive system."[26]

Chantel is clearly thrown off her course because of the pregnancy. She does not know what to do, or how to handle the situation or her emotions; she admits that to us. There she was at seventeen with all her dreams, heading full-speed toward her future, feeling completely in charge and invincible. Having a baby was not part of her plan, and she lets us know that she "messed up." One of the options presented to her to solve this "problem" was adoption, which she refuses because she insists that she cannot give up a child after carrying it for nine months and enduring a painful delivery. She confides in us during her struggle with this new twist in her life, depleted of the energy she had in the earlier scenes, her strong and sassy voice now a mere whimper. As she sits almost motionless on her bed, facing a wall, turning slowly to acknowledge us, she admits her denial about the situation. She admits that time passed and she did nothing, convincing herself that she was not pregnant, that this was a dream, and that it would pass.

In order to complete her denial, Chantel tells her best friend Natete that she is not pregnant at all. She carries on the fantasy, buying a girdle and larger-sized clothes to cover her weight gain. We note the change in her character: We also note that she becomes reclusive, her demeanor changes, and she becomes an entirely different person, defeated, it seems, by the situation.

Tate obviously favors the film, and manages to rate it on its own terms. "When was the last time you saw a black woman carry a picture? When was the last time you saw a sister given a chance?" He appreciates Ariyan Johnson's heavy-duty portrayal of Chantel for what she is, and places the character in a context that not only describes but suits her: "*Just Another Girl* is Johnson's show and she bumrushes it with all the obnoxious buoyancy of a double-platinum rapper."[27]

Although the film was both hard-hitting and disturbing at points, for some Hollywood executives, it lacked the necessary ingredients previously dictated by the genre it was supposed to emulate. According to these industry executives, this was to be a 'hood film, from a female point of view. It was supposed to deliver the same goods as *New Jack City*, *Boyz N the Hood*, and *Menace II Society*, with one exception: This was about a Black woman, from a Black woman's point of view as director. Mark Healy explains: "When studio executives read the script, they wondered where all the violence, drugs, and guns were. *That* story, Harris insisted, had already been told."[28]

To secure a more useful understanding of Harris' agenda for Chantel and to secure a more reasonable placement for the film's efforts, we will turn now to Jacqueline Bobo. In her essay "Reading Through the Text: The Black Woman as Audience," she makes legitimate points about the media in relation to Blacks. In a section called "Ideological Construction," she discusses the work of Black women in relation to the media. In many ways, this treatment resembles and explains the antagonistic relationship between Chantel and supposed television reports in *Just Another Girl on the I.R.T.*, as well as the real-world attitude toward her irrepressible irreverence. "The ideological intent of media representations of Black women's lives is to maintain the status quo by resurrecting previously demeaning images of them. The process has a history in media depiction's of Black people in general,"[29] Bobo contends. Taking into account Tate's analysis of *Just Another Girl*, that Chantel has "rude-girl authority," we can foresee the resistance to her nature and character, based on Bobo's assessment. As mainstream attitude would have it, then, Chantel's headstrong rebelliousness would be beaten out of her much like the character played by Oprah Winfrey in Spielberg's *The Color Purple*. Since this was not the case, other measures had to be taken. Bobo continues her point, further defining the representations and the need for their suppression: "Anything that could be seen as an ideological corrective had to be neutralized and contained."[30]

It is easy to relate these ideas to Chantel, who is seen by many, including some of the characters in the film, as "threatening the established order,"[31] and, since she was neither neutralized or contained, other forces, foretold at the beginning of the film, would be brought against her. It becomes clear that after an interpretive approach to the essay, which is primarily an analysis of *The Color Purple* (an adaptation of Alice Walker's book of the same name), several of Bobo's points can be transferred to Black women's issues in general. An important example is the issue of Black female sexuality, which she notes in the following: "Negative constructions of Black women's sexuality have been the cornerstone of many oppressive ideologies that are used to mask capitalist, racist, sexist motives."[32] Bobo gives us a historical perspective on empowering Black women in literature, which translates easily to the cinema, and specifically to this film. "Black women's novels," she writes, "were a product of a conscious effort to portray multidimentional characters who attempted to attain some measure of control over their lives."[33] This has to be one of the primary goals of African American cinema, particularly for Black women as well as for their female characters. This issue is relevant whether

a film is placed in the rapid currents of the industry mainstream or the less restrictive independent movement. Finally, Bobo insists that "[t]he critical issue then becomes one of how to affect the reception to the works so that they are not seen in isolation but in relation to the total lives of Black people."[34] This is the real challenge for industry executives and critics alike, a challenge decidedly not met with Harris' film. This big-picture perspective, if allowed to develop, could alleviate many of the pressures placed on African American cinema by Blacks and Whites alike.

Just Another Girl on the I.R.T. stands, within the narrative and outside with the life of the film, as a superb example of the double consciousness that African American cinema exposes. It is a position cognizant of being "watched." As the opening of the film suggests, the story the media might present about any subject is often more complex. In this particular case, it is this film's goal to try and explain some of the details and circumstances surrounding Chantel's story to the audience. The point Chantel makes about the media from the film's outset is from a position both "inside" and "outside" the narrative. Although she never mentions the media again, the theme never dissipates. Throughout the film, Chantel reminds us of her awareness of the fact that she is constantly being observed and judged.

The best and most obvious example takes place shortly before she enters the train for one of her trips home. She stops to chat with the audience, standing with hands on her hips and chewing gum as always. She reports on a recent train ride with her friends, conveying how it feels to be stared at for having a good time. She also tells us that she interprets these stares as being very judgmental. At this point, Chantel leans over and really pulls the audience into her confidence, *entre nous*, to let us know that she is angry. She questions how people can feel that they "know" her just by looking at her and laughs as she informs us how surprised people are when some find out how smart she really is. Chantel laughs again, and walks on to meet her friends. This confidential chat exemplifies her struggle with negative stereotypes. She must constantly resist the image others have of her, most notably the media.

Harris in *Just Another Girl on the I.R.T.* is clearly interested in giving voice to this young woman as a representative of a group normally not permitted to speak for themselves. In another attempt to define and strengthen this position, the director gives her main character the power and authority to critique the image others have of her. The film also presents productive examples of notions outlined by bell hooks in "The Oppositional Gaze: Black Female Spectators." For hooks, these notions

are very much connected to Black films in general. From her point of view, "It was the oppositional black gaze that responded to these looking relations by developing independent black cinema."[35] It would be a mistake, however, to think that this priority does not exist in commercial Black cinema as well, where empowering Blacks is even more essential.

Indeed, hooks' point proves to be a salient one, no matter what the story or sex of the main character. This act of looking or being observed does not go unnoticed according to hooks, who claims that, in reality, someone is always watching. This is the same sentiment that Chantel manages to express when she suggests that we might hear about what is going on in her neighborhood in the papers or on television. Unlike Doughboy in *Boyz N the Hood*, she understands and accepts that the media will misrepresent the events taking place as we watch. The film is positioned in a way to confront the fact that not all the facts will be explained completely or fairly.

The fact that there was a shortage of African American women filmmakers in the mainstream was not all that concerned hooks. From her point of view, there was not enough attention given to Black female spectators. "The prolonged silence of black women as spectators and critics," she claims, "was a response to absence, to cinematic negation."[36] The most helpful point that hooks makes is her description of the "gaze," its meaning, and how to contend with it. "Spaces of agency exist for black people, wherein we can both interrogate the gaze of the Other but also look back, and at one another, naming what we see. The 'gaze' has been and is a site of resistance for colonized black people globally."[37]

One socially significant way to position *Just Another Girl on the I.R.T.* is in terms of this "gaze." In the very first moments of the film, Chantel defines it in relation to the media. As the story develops, we learn to recognize its persistence in her daily life. This film is truly, as hooks defines it, interrogating the gaze of the "Other." What this young irreverent woman sets out to do, as the film's main character, is oppose the details of this "looking." When Chantel promises to show the viewers "the real deal," we can equate that in a way to resisting by looking back at the very gaze haunting or taunting her. Hooks explains this in other terms: "The extent to which black women feel devalued, objectified, dehumanized in this society determines the scope and texture of their looking relations. Those black women whose identities were constructed in resistance, by practices that oppose the dominant order, were most inclined to develop an oppositional gaze."[38] Chantel is the personification of this oppositional gaze. Her direct address to the camera or audience is further proof

of her self-assured audacity. Harris, herself a veteran spectator, creates work, whether knowingly or not, from the position of a Black female spectator. A film director's point of view, developed over many years as an observer, is revealed more profoundly as he or she is transformed from spectator to creator. We can say with a fair amount of accuracy that first features usually take on this particular intensity. An artist or filmmaker will always be influenced by what he or she knows of society, its rules, and its boundaries. This will appear in the texture of their work. Both Chantel and Harris represent the experience of living outside the mainstream, outside the White world, outside the gaze of the dominant media. So, when given the chance to speak, in this case through film, the dominant storytelling tool of our time, each will approach that chance with even more intensity. Speaking from the position of a Black female spectator, Harris says, "I made this movie for young black women who haven't seen themselves represented on film," she says. "I made a movie *I* wanted to see."[39]

That being said, it would be unfair and incorrect to assume or derive from any observations made here that exclusion or disenfranchisement is the only reason for Blacks to create art. Black artistic movements are not merely reactions to the negative forces that surround their existence, not merely works of resistance, although they can also stand as such. For hooks there is more than resistance at work. "As critical spectators, black women participate in a broad range of looking relations, contest, resist, revision, interrogate and invent on multiple levels, she writes."[40] In closing, hooks makes the following statement that suits Chantel well: "Looking and looking back, black women involve ourselves in a process whereby we see our history as counter-memory, listing it as a way to know the present and invent the future."[41] Clearly, Chantel does not want her story told by the media, or anyone else for that matter. No one else is permitted to write her history, dictate the circumstances of her life, or speculate on her future based on any observations about the present. Ironically, the character manages to exist seemingly free of even the director's control, which is a real testament to Harris' skill. Harris has not created a monster, as some critics may claim, but a forceful young Black woman who is still developing—she wants to speak for herself, uncensored, without mediation. That is the point of the film. Chantel resists notions of who and how she should be, in order to be. Chantel understands her situation, this is clear, and with a little bit of patience and generosity, so can we.

Notes

1 bell hooks, *Black Looks* (Boston: South End Press, 1992), 115.

2 Lawrence Cohen, "Blacks Taking the Helm," *Variety,* 18 March 1991: 1, 108.

3 Veronica Chambers, "Finally, a Black Woman Behind the Camera," *Glamour* (March 1992): 111.

4 Bronwen Hruska and Graham Rayman, "On the Outside, Looking In," *New York Times*, 21 February 1993, p. 17.

5 Manthia Diawara, "Black American Cinema: The New Realism," in *Black American Cinema*, ed. Manthia Diawara (New York: Routledge, 1993), 13.

6 Sheila Rule, "Director Defies Odds with First Feature, 'Daughters of the Dust,'" *New York Times*, 12 February 1992, sec. C, p. 15.

7 Ibid.

8 Ibid.

9 Phyllis R. Klotman and Gloria J. Gibson, *Frame by Frame II* (Bloomington: Indiana University Press, 1997), 688–700.

10 Donald Bogle, *Blacks in American Film and Television* (New York: Simon & Schuster, 1988), 438.

11 Amy Taubin, "Girl N the Hood," *Sight and Sound* (August 1993): 16.

12 Chambers, "Finally, a Black Woman," 111.

13 Rule, "Director Defies Odds," 15.

14 Taubin, "Girl N the Hood, " 16.

15 Ed Guerrero, "A Circus of Dreams and Lies: The Black Film Wave at Middle Age," in *The New American Cinema,* ed. Jon Lewis (Durham: Duke University Press, 1998), 342.

16 Greg Tate, "Flygirl on Film," *Village Voice*, 23 March 1993, 58.

17 Todd McCarthy, "Just Another Girl on the I.R.T.," *Variety*, 21 September 1992, 84.

18 Taubin, "Girl N the Hood," 16.

19 Terrence Rafferty, "Tunnel Vision," *New Yorker*, 22 March 1993, 102.

20 Ibid., 103.

21 Julie Phillips, "Growing Up Black and Female: Leslie Harris's Just Another Girl on the I.R.T." *Cineaste* 19, no. 4 (1993): 87.

22 Ibid., 104.

23 David Denby, "Portrait of the Artist as a Big Bore," *New York,* 5 April 1993, 61.

24 Taubin, "Girl N the Hood," 17.

25 Jacquie Jones, "The Construction of Black Sexuality," in *Black American Cinema,* ed. Manthia Diawara (New York: Routledge 1993), 254.

26 Tate, "Flygirl on Film, 58."

27 Ibid.

28 Mark Healy, "Fly Girls on Film," *New York*, 25 January 1993, 24.

29 Jacqueline Bobo, "Reading Through the Text: The Black Woman as Audience," in *Black American Cinema*, ed. Manthia Diawara (New York: Routledge 1993), 273.

30 Ibid.

31 Ibid.

32 Ibid., 274.

33 Ibid.

34 Ibid., 286.

35 hooks, *Black Looks*, 117.

36 Ibid., 118.

37 Ibid., 116.

38 Ibid., 127

39 Healy, "Fly Girls on Film," 24.

40 hooks, *Black Looks,* 128.

41 Ibid., 131.

Chapter Six

Menace II Society

Albert and Allen Hughes, 1993

"There's too many movies about cops saving the world, which isn't true. There's too many movies about good prevailing over evil, which isn't true either. More times than not, there's evil kicking good's ass."[1]

Allen Hughes

The Hughes Brothers' debut film, *Menace II Society* (1993), represents, according to the directors, a dramatic alteration of the Black urban genre. Says Albert Hughes, "We don't want to be second-guessed by people, as far as saying, 'Oh, it's another hood film, who cares?' Or they say, 'It's not positive.' We're not out to make positive films, or preach and propagandize to the Black community. It's limiting."[2] Nelson George agrees with their assessment of the film: "These young filmmakers succeed in complicating the positive versus negative image debate by putting at the core of this male story a vibrant female presence."[3] If this is indeed the case, and we can argue that it is, then the film would position us, thematically and cinematically, in a distinctly different urban space.

Most of us may experience the film's relentless, complex, and at times confusing barrage of violent events and ghetto ideals with great trepidation. Much like the other films discussed here, *Menace II Society* follows in part the tradition of the Hollywood classics and, of course, the most palpable forces in contemporary African American cinema. It is clearly intended for, and representative of, the Black urban youth in America, yet critics acknowledge the fact that the directors' vision and agenda differ from the rest. This is not another "message" film. "In other words," says George, "*Menace* is not for the NAACP Image Award crowd."[4] The shock waves from *Menace II Society* were felt throughout the film industry, and viewers realized immediately that this was a force to contend with. Again George concurs, noting that the directors, screenwriter (Tyger Williams),

and cinematographer (Lisa Rinzler) "have perhaps concocted the most violent film by and about African Americans to date."[5]

Not since Spike Lee's *Do the Right Thing* have we seen such powerful, confusing, and disquieting images. This film's skillful and explosive agenda, however, was not always apparent or acceptable to viewers, since it loomed as too fatalistic for most. David Denby, who, experience tells us, is not always on the mark when offering an interpretive critique of African American films, reads the signs more clearly in *Menace II Society*. He notes that "[t]his film has a fuller and more wrathful understanding of the nihilism of the ghetto than anything else we've seen in movies."[6] Albert and Allen Hughes did not intend to make this an easy picture, and in an interview with Bernard Weinraub, they clarify their position: "Our intention was to have the audience turn away."[7]

Indeed, the film offers us the grimmest of realities and exposes the most difficult scenario in African American cinema, and what it does very successfully is to leave us in the horrors of this Black ghetto, where death seems to be the only escape. What we are faced with at film's end is the undeniable fact that the directors have, skillfully, publicly, violently, and with no apologies, condemned the film's characters without hesitation or remorse. For Robert Marriott, *Menace* "in essence, reads like a generational suicide note."[8] He explains further: "Getting seduced into sacrificing the whole for the sake of the fragment by emphasizing the death element of black reality, *Menace* blatantly and subtly suggests there is no hope, no humanity."[9]

This leaves us, at best, in an untenable position. For audiences, critics, or cultural historians for that matter, to confront the positing of young Black men as a "menace 'to' society," an act executed by young Black men, presents an awkward cultural, political, and social situation. This, coupled with the film's artistic skill, leaves us nursing a great ethical dilemma. It seems that with *Menace II Society*, all the fears navigated in the positive-negative debate, issues of representation and stereotypes, had finally materialized. Comparing *Menace II Society* to any other African American film or to any one of the classics in the gangster genre that may have informed its structure and style is a challenge. Yet, says Paula Massood, we cannot examine the film "without referring to other films within the 'hood' or 'gangsta' genre."[10]

However, a broader perspective addresses the film's agenda best. Terrence Rafferty, for example, manages to see a relationship to Louis Bunuel's *Los Olvidados* (1950), which, he argues, "is the clearest-eyed and the most harrowing exploration of the cruel exigencies of poverty

ever put on film."[11] Even though many would simply reject *Menace II Society*'s basic premise as well as its brutal ending, they cannot reject its attention to craft. It is, and will remain, a crucial film in the development of African American as well as American cinema. So, according to the directors, the point of the film is not to deliver a specific social message or depictions of Blacks that are either negative or positive. However, we can ask what politics the audience will develop toward the film's gangster, O-Dog, who manages to wreak apocalyptic havoc on his community of friends and survive. And, more importantly, does this make socially responsible sense?

The film presents several skillfully composed and orchestrated media sequences nestled deep in the busy fabric of its grim yet artful tale. *Menace II Society* has more media events than encountered in any single film discussed here thus far. To list them individually is to begin to understand one of the many complex layers of the film. The first media encountered is the footage of the 1965 Watts Riots, which is intended for the viewers and is presented without character mediation. The second is Nicholas Ray's film *They Live by Night* (1948), mediated by Caine, who watches uninvolved from his hospital bed. The third, Frank Capra's *It's a Wonderful Life* (1946), navigated again by Caine, his grandparents, and O-Dog. And finally, there is the surveillance videotape that witnesses the killing of two Korean grocers.

Many of the other elements in the film are not new. We have experienced inhospitable lawless urban terrain before. We have had previous and ongoing cinematic experiences with modern-day self-destructive gangsters who often perish violently. We have certainly seen innocent people killed, and we have been exposed to highly explosive and ultimately tragic human dramas, coming-of-age sagas, and rites-of-passage dilemmas. Of course, navigating the emotional spaces in this film presents, even for the most practiced and experienced viewer, an almost untenable task, particularly because of the skillful and relentless intensity of the film. That is the point.

However, for Playthell Benjamin, who laments the use of Black talent for such morbid and overused themes, the film presents a problem. His most salient point, one that concerns this spectator most, deals not only with form and content, but with authorship as well. "Though *Menace* is powerful from purely artistic p.o.v.," he writes, "it offers nothing new by way of insight into the problems of the black lumpen; it's just bloodier and the murder more casual. . . . Saddest of all, they are perpetuating this image themselves, as if self-destructive impulses were contagious."[12]

Albert and Allen Hughes may have been new to feature films, but they had extensive experience with the medium, beginning at the age of twelve. The two eventually fine-tuned their talent, making short films and rap videos. Their unyielding dedication to doing something completely new with familiar cinematic techniques was intense, but *Menace II Society* met with a great deal of disapproval. The mainstream media image police had encountered nothing like this before and, even though stunned by its grim velocity, managed to utter disdain regarding the filmmakers' handling of the material. Georgia Brown offers us her thumbs-down *Village Voice* review: "Not only do I dislike *Menace*'s racism, I don't like the way it caricatures Caine's grandparents, who presumably are all that stood between his destiny and O-Dog's. (You can repudiate without ridicule.)"[13]

Because the film is difficult to watch, is hard-hitting emotionally and philosophically, and its ending is almost impossible to accept, it is important to decipher the directors' intentions as we proceed with an examination of the film's impact. Brown details some of their more competitive motives. "Clearly they considered *Boyz* sappy and preachy, about winners and weepers, and want to treat the real, hard thing itself, and in a way that audiences can't be complacent about."[14]

It seems that *Boyz N the Hood*, like *Do the Right Thing* before it, had set another standard in African American filmmaking. It was clear that we had reached a new realm with *Menace*. These young Black filmmakers had revised the notions of purpose and value. Allen and Albert Hughes were interested in making powerful cinematic images and proceeded on their own terms, under the cloak of irreverence, with unquestionable skill and unrelenting determination. Even more challenging than watching the film itself is our examination of the rapid succession of media elements. Although many in number, these moments present us with one viable and tangible way to unearth the film's position. If there is a message in the film, lost beneath the rapid barrage of violence, the intertextual or reflexive elements may offer some semblance of meaning. Certainly, a thorough examination of these moments enables a more timeless comprehension of the filmmakers' political statements. While the tools they engage may be similar to those used by their predecessors, Allen and Albert Hughes have very different ideas about the use of media in their story.

Menace II Society, like *Boyz N the Hood*, is about young Black men growing up in the American West, in neighborhoods that can be called modern-day frontiers. For these young men, there is little hope of a productive or successful future, in the way that we understand it. No Ameri-

can dream. The main characters are O-Dog (Larenz Tate), Caine (Tyrin Turner), and Ronnie (Jada Pinkett). The story takes place around Caine's graduation from high school and proceeds through the summer. The narrative follows Caine into three sectors of his life: at home with his grandparents, with Ronnie and her son, and with O-Dog and the gang, but the focus of the film is on the latter constellation. Two of the media scenes bear some similarity to the intertextual moment in *Juice,* where the action and narrative attention is focused on the characters watching television. In one case, however, we observe them watching not a classical Hollywood gangster film, as tradition would predict, but Capra's *It's a Wonderful Life* (1946). In another it is the surveillance videotape of O-Dog killing the Korean couple, and like *Juice*, they move from classical fantasy to present-day reality.

American audiences are indeed accustomed to stylized violence in movies, but are more familiar with, that is, spend more time watching, the evening news. News reports depict a very real and violent history in this country, and the news media has been featured as an essential part of all the films discussed here, sewn deep in the fabric of each story. In an effort to have the audience relate to the impact of media and the history of violence, the Hughes Brothers manage to get our attention early in the film. They accomplish this with two distinct acts of violence—both captured on film or tape—the killing of the Korean couple and footage of the Watts Riots. While this may be an attempt to alert us immediately to violence as a given, its significance reveals other points of view in relation to the film. What is signaled by the Watts footage, actual events where we note the use of violence against Blacks? Regardless of the directors' intentions, what this does, positioned so quickly after O-Dog's brutal murder of the Koreans, is posit the notions of violence as a historically popular instrument used to contain Blacks. This Watts footage juxtaposed with other forms of violence suggests a historic process that leads to the present-day realities of Black-on-Black violence. Simply put, real violence dwarfs the fictional cinematic violence, which leaves little room for the gangster picture in the film.

Menace II Society, like *New Jack City* and *Juice*, has its origins in the American gangster formula, although we have no obvious connection via the usual "homage." The audience is not encouraged to make any link between Caine and any film gangster placed conveniently on the television screen to offer clues to his nature. We will have to find the key to his character elsewhere. His actions are associated with real-life gangster mentors Pernell and O-Dog (who spends more time watching his own

image on television). Nonetheless, critics did observe connections to classical Hollywood formulas. "The movie isn't interested in tragic irony; it aims, instead, for the throwaway, life-is-cheap tone of grimy fifties B-pictures, like the brutal pulp thrillers that Sam Fuller made in his heyday,"[15] writes Rafferty in the *New Yorker*.

The *Mean Streets* and *Scarface* influences seem to be easily detectable and therefore mentioned more frequently in reviews. Denby makes the comparison immediately in the title of his article, calling it "Mean Streets,"[16] while Amy Taubin manages to expend more energy detailing the relationship.[17] To assess George's sentiments toward the picture, one need only read the title of his article, "Menaces to Society: Brothers Grim—the Hugheses' Film Is Hip-Hop Dark."[18] He, too, notes the connections to the classic pictures, pointing out the brothers' personal relationship to individual films as well their real affection for the art in cinematic material.

Menace II Society is primarily about Caine Lawson (Tyrin Turner), although O-Dog appears in as many scenes and is truly the driving force in the narrative. Most of the events that take place evolve and revolve around his explosive actions. However, this is Caine's story; he is the narrator, and we witness the unfortunate circumstances that concoct his troubled existence, including an introduction to his father (Samuel L. Jackson), drug-dealer and murderer, his mother, a drug addict, and Pernell, his gangster mentor. Later on, as we return to present day in the story, we encounter details about his best friend, O-Dog, whom he classifies as "America's nightmare." In the film, Caine moves from confused and frightened observer to criminal. O-Dog is able to murder without hesitation; for him, life is simple: Kill or be killed.

We begin *Menace II Society* with the sound of male voices spouting the now familiar verbal violence while we move from the New Line Cinema logo to a black screen. Our first visual is the fluid tracking of O-Dog and Caine entering a grocery store. We follow them in a smooth and swift low-angled medium two-shot as they enter and go to the upright refrigerator containing beer. As they arrive at the case, it is evident that a Korean woman is closely observing their movements while dusting bottles. The two make note of her, and O-Dog addresses her saying: "You ain't gotta be creepin! I don't know why you're acting like you cleaning up." As he opens the upright door to the beer case, he mutters, "Damn, always think we're going to steal something!" Under watchful eyes, they pick out their beer and proceed to open it before reaching the register. A pan from the two-shot reveals the Korean man behind the register/counter, who informs them in broken English that they are not to drink the beer in the

store. There is another quick pan back to the two moving toward the register, while O-Dog informs him angrily that he is going to pay for the beer. The woman follows as we cut to O-Dog, who turns and tells her to stop following him. The camera cuts to her as she says, also in broken English, "Hurry up and buy," and then there is a quick cut back to the two as they continue moving forward.

As they approach the register, the man is heard saying, "Just pay and leave," to which O-Dog responds, as he nears the register, "Hey, man, I said I'm gonna pay you, why don't you calm your nerves?" The man continues rushing them as the woman maintains her close vigilance. Finally, they reach the counter, as the tension mounts. O-Dog says something inaudible to Caine, who reaches into his pocket while O-Dog turns to watch the woman. The camera cuts to a medium close-up of her watching them, then to an establishing medium long shot of the four. To the right and closest to the audience is the woman with her back to the camera observing the scene; center frame are the two young men; and to the left, furthest from the camera and behind the register, is the man. An over-the-shoulder through the two young men reveals the store owner keenly watching them as he leans forward. We then cut to a low-angle reverse shot of the two as the man picks up the money that Caine placed on the counter. Simultaneously, Caine picks up his already open beer and asks his friend to get the change; he heads toward the front door while O-Dog continues behind, stopping to get the change. The tension is now unbearable, and the audience anticipates an escalating situation while hoping that they leave without incident. The camera cuts to the Korean man, who says he does not want any trouble and asks them to leave, as O-Dog picks up the change. O-Dog remarks that he can't stand "them," as we cut back to a medium shot of the Korean man saying that he feels sorry for O-Dog's mother. We immediately cut to O-Dog, turning as the camera swings up to a close-up of him. Caine is in the background drinking his beer. From the camera's movement and the look on O-Dog's face, we know that a definitive moment is upon us. O-Dog, now facing the man, asks him what he said. Before he completes this sentence, we cut back to the man's face, grimacing with his response. He repeats his wish not to have any trouble and asks them to leave. As we return to the previous establishing shot with the woman to the right and the man to the left, we observe O-Dog walking back toward the register. As a screaming match ensues between the two, we cut to a medium shot of Caine with the forty-ounce bottle of beer overturned on his lips. The camera zooms in on him, and the mo-

ment is pierced with a gunshot as the bottle falls from Caine's hand and the camera makes a quick cut to a close-up of it smashing on the floor.

A close-up of O-Dog's shoulder, his right hand extended over the counter firing shots from a gun toward the floor, further informs us. Removing his hand, O-Dog moves toward the rear of the store, and the camera pans slightly to the left to reveal the woman with her hands on her head leaning toward the floor screaming. O-Dog takes hold of her shirt as he passes and drags her toward the rear while demanding that she give him the videotape. He shouts to Caine to get the money out of the cash register. We cut to a medium shot of Caine, obviously in distress, approaching the counter and looking over to see what happened to the man. We then cut to his point of view as the camera tilts over to reveal the man lying in a pool of blood with a gunshot to the head and two to the chest. The camera cuts back to Caine's contorted face while he looks toward the door and back at O-Dog, now entering the back of the store. We cut back to Caine, who looks as if he is panicking, raising his hands, asking O-Dog what he did. The camera cuts back and dollies toward the empty rear entrance, as we hear O-Dog yelling at the screaming woman. Finally, as we near the entrance, the camera stops, and we hear the final shots. O-Dog bursts from the rear, runs behind the counter, stepping over the man's body, toward the cash register, which Caine has not attended to. As he stands there, we notice the videotape tucked in the waist of his pants and Caine backing up with his hands on his head.

In a series of quick cuts, we watch O-Dog open the register, only to find six dollars, while Caine urges him to leave the store. O-Dog, angry at the small find, kicks the dead man and bends over him to empty his pockets. O-Dog now stops to chide the dead man, and Caine runs out of the store, followed by O-Dog, who jumps over the counter to make his escape, taking his beer before leaving. As we follow O-Dog out of the store, the camera stops in the open doorway, and we are left there, the camera still pointed at the empty street, as we hear Caine's seemingly peaceful and ironically quiet voice-over as a screeching car and police sirens break the silence. He talks about the irony in going to buy beer and leaving as an accessory to two crimes. He says you never know what would happen or when, and admitted that he knew then that it would be a long summer.

As the voice-over ends, the scene fades to black, the credits begin as the audio tells of the violence newscast-style. The sequence that follows the opening credits is our first encounter with media. Quickly, we move to scenes of Watts in the 1970s, again labeled by subtitles, to observe criti-

cal moments in Caine's childhood, which he narrates for the viewers. Here, the historical background holds ironic significance. He explains that when the riots stopped, the drugs started and that "family" life, instead of keeping him out of trouble, turned him on to it. The rest of the scene shows Caine at home in his pajamas. We meet Pernell and Caine's mother and observe as the boy witnesses his first murder—when his father shoots a man during a card game. Moving on, we arrive at present-day Watts, 1993, and see daylight for the first time in the story. The audience enters a classroom where Caine endures his final day of high school. After class, we meet Ronnie (Pernell's girlfriend), her five-year-old son, and Caine's grandparents, who have responsibility of raising him since his parents' death.

As we get to know Ronnie, we perceive a new and much improved African American female character. She is certainly the most interesting and complex Black urban female so far in the group of films discussed here. None of the women in *New Jack City*, *Boyz N the Hood*, or *Juice* is as confident, independent, or integral to the story. Not everyone would agree, but George notes some of her positive elements: "In Ronnie (portrayed with wonderful clarity by Jada Pinkett), the mother of a little boy whose father Pernell (Glenn Plummer) was Caine's criminal mentor, the Hughes have created the kind of black female character you find neither in black film nor rap music."[19] Brown, on the other hand, is critical of the character, reading her as confused, conflicted, and ineffective. While her reading is negative, her questions about the character's motivation are important: "One minute Ronnie kicks Caine out for instructing her kid in the use of his gun, the next she's proposing."[20] It is not difficult to imagine a woman angry at the man she loves for showing her five-year-old son how to use a gun. Given the reality of their daily lives, it makes a great deal of sense. Nor is it implausible that she, as Brown criticizes, would give a party to say farewell to the people she grew up with, and the fact that she has manners and lives in the ghetto is neither strange nor unfathomable. It is unfortunate that Brown finds no value in a female character who adds to the overall status of Black women in the genre. Ronnie is a woman who actually has a role to play in the film's community and story. Of course she has faults, but she is one of the few people in the film who wants to, and in fact does, survive. More importantly, she is given screen time. For Ronnie, improving the circumstances of her life and that of her son are real and achievable goals. Denby offers his support, noting that "she's meant to be the only sane and responsible person in Caine's circle, and Pinkett plays her with conviction and force."[21]

As we navigate the scenes to follow, we encounter a barrage of media events woven tightly and effectively into the narrative's already quick pace.

Caine and his cousin Harold attend a party. As soon as Caine arrives, he learns that O-Dog has been showing the surveillance videotape of the murder, and he talks to him about it immediately. We spend very little time in the scene, just enough to be introduced to the other young men in the film and to follow the main characters as they depart to attend another party. Caine travels in Harold's car, and on the way, while stopped at a red light on the now infamous—thanks to *Boyz*—Crenshaw, they are both shot in a robbery. Harold is left to die in the street, and Caine is rushed to the hospital. Later, as we enter Caine's hospital room, his narration continues. He details his shock about being shot, seeing so much blood, and in the panic, believing that he was going to die. He tells us that he spent most of the two-week hospital stay thinking about his cousin and watching gangster films. During the voice-over, the camera revolves in a semicircle around Caine, seated on his bed and shirtless, eating something out of a cup and glancing at a TV offscreen. As he completes his voice-over, the camera shows his profile, then cuts to the television mounted on the wall where we see the film. The audience is given a quick clip from Ray's *They Live by Night* (1948) and can only distinguish that two men are talking and that one is a police officer. The scene takes place at night, and the officer is asking the other man for identification. The man offers to show his army discharge and pulls out a gun instead and shoots the officer. The rest of the scene is confusing, and we cut back to Caine as he responds to a knock at the door. Ronnie has come to take him home.

The relationship between *Menace II Society* and *They Live by Night* is not clear from the short clip alone. If Caine did not make a point about staying up and watching gangster films, the audience would not have noticed. In order to make stronger ties, one would have to be familiar with the Ray film, which is a story about young people in the criminal world. The most similar elements are the male and female relationship, which could be compared to Ronnie and Caine, and a male duo, comparable to Caine and O-Dog. One interesting note is the similarity between O-Dog and T-Dub in Ray's film. Frank Krutnik encapsulates the story: "Their romance, however, is doomed by their alienation from society and because Bowie finds himself unable to resist the influence of Chickamaw and T-Dub."[22]

The most noticeable alteration to the reflexive theme thus far is that Caine watches the movie alone, almost numb to the action, showing no response or connection except for the narration. We are offered none of the clues that were present in *New Jack City*, where Nino Brown emulates *Scarface*'s Tony Montana, or in *Juice*, where Bishop celebrates Cagney's actions in *White Heat*. Rafferty interprets Caine's numbness to

Ray's film: "Caine's aspirations are shockingly low; he doesn't even dream, as the heroes of thirties and forties gangster movies did, of criminal glory."[23] It is likely that the Hughes Brothers intended the sequence to read this way, resisting, as they have, other conventions and patterns in both genres. In any case, Caine already had a real-life gangster hero and mentor in Pernell. The filmmakers no doubt avoided repeating the "homeboy idolizing Hollywood gangster" scene encountered before in contemporary Black films, once again showing their resistance through Caine, who is past the fantasy stage.

Shortly after we arrive at Caine's grandparents' house, we are greeted by another television. In a medium close-up of the living room, nestled between a few pieces of furniture, the screen is alive with Capra's *It's a Wonderful Life* (1946). The film is near the end, when James Stewart's character, George Bailey, returns home from his nightmare, desperately looking for his children. As George runs up the stairs to embrace them, we cut to Caine's grandfather in a dark silhouette looking at the screen, then quickly to a two-shot of Caine next to his grandmother on the couch. She is smiling and obviously enjoying the film, while Caine has a look of dismay on his face. Quick cuts back and forth end in a two-shot where Caine is now looking directly at his grandmother in disbelief. He is clearly perturbed and contorts his face to indicate his feelings. The camera cuts back to a close-up of the television where George, surrounded by his loving family, enjoys the gleeful moment. Then we cut back to the two-shot and a knock at the door. Caine, happy to leave the film, gets up to answer it and lets O-Dog in. Before they can make their escape, grandfather invites them in and, as O-Dog sits on the couch, he glances at the film, revealing no reaction. Grandfather turns off the television, and grandmother gets up to let the men talk. The two are lectured about the trouble they have been getting into and told that the Lord did not put them here to kill each other, quoting the commandment from the Bible, "Thou shalt not kill." Caine tells him that he has never killed anybody; and his grandfather says he doubts that. He then turns to O-Dog and says he has heard stories about him. O-Dog replies respectfully, telling him that God doesn't care about them. Caine's grandfather continues his talk as we cut to Caine, camera pointing upward, showing a picture of the Last Supper behind him. He slowly leans forward, dropping his head into his hands, zoning out on the "talk," commenting in voice-over on his grandfather's constant use of religion and how it goes in one ear and out the other. As the two leave the house, Caine's grandfather steps into the doorway, calls Caine, and asks if he cares whether he lives or dies. Caine turns, thinks for a

moment, and answers after looking at the ground for some seconds, genu-
inely confused, saying, he doesn't know.

Clearly, Caine's more obvious emotions toward *It's a Wonderful Life*
bear more significance to the story than *They Live by Night*. This is
evident from the directors' handling of the sequences, from the time spent
on each film, and from subsequent reactions. Even more telling was the
grandfather's question to Caine and his answer. Caine rejects *It's a Won-
derful Life* and its premise in order to make the point that there are no
happy endings in the 'hood. *It's a Wonderful Life* is about a man's tri-
umph over poverty and adversity. It is about a man's life having meaning,
even though he is unable to fulfill his lifelong dream of escape from his
small town. It is about survival, albeit with the help of a guardian angel
about good triumphing over evil, second chances, community bonds,
and, of course, love and family. Remember Allen Hughes' words and
understand Caine's position: "There's too many movies about good pre-
vailing over evil, which isn't true either."[24] Caine's refusal of the film is a
refusal of its premises encoded in the title. Coupled with this is his rejec-
tion of religion, even though he wears a cross. O-Dog's arrival and speech
are intended to be an ironic reality check for Caine. This forces our main
character to navigate two extremes and to confront the issues while try-
ing desperately to find his place. In essence, he must chose between his
grandparents' way of life (framed by religion and *It's a Wonderful Life*)
and the one offered by O-Dog (framed by the surveillance videotape).
This moment is finally resolved when Caine is called back to answer his
grandfather's question, "Do you care whether you live or die?" Caine is
forced to respond, and what is shocking about how the scene ends is that
he is clueless.

As the young men depart, they talk about Caine's gunshot wound, and
O-Dog tells him that he knows where his cousin's killers are. He then asks
him if he "is ready" to avenge Harold's death. From here, we cut immedi-
ately to the black-and-white surveillance videotape being screened again.
It is significant to note that this is the first time the audience is permitted
to participate in its viewing. As it plays on the television, the audience can
see the area around the cash register and the three men—Caine, O-Dog,
and the Korean grocer. There is no audio, but it is clear that O-Dog is
arguing with the store owner, while Caine is in the background drinking
his beer. We hear the male voices of the group commenting on the events,
making fun of Caine drinking his beer, as we cut to a medium shot of O-
Dog saying, "Hey! hey check this out check this out. . . Boom!" and
quick-cut back to the tape, where we see O-Dog for the first time putting
the gun to the Korean man's head and shooting. We cut back to O-Dog

saying, "Yeah!" then back to the tape as he fires several other shots. We then pan over to the couch to see the others and make note of Caine's anger as O-Dog celebrates. The scene reads almost as a reenactment of *Juice*, since Bishop and O-Dog react in the same way to images playing on television. Someone in the room asks for a dub, and O-Dog says he'll "sell copies for $59.95." In the next scene, Caine is sitting alone in the back seat of the car, telling O-Dog again and more emphatically to stop showing the tape. For Caine, the seriousness of the tape does not coincide with its treatment by O-Dog, who views it like a favorite blockbuster hit. For O-Dog, "America's nightmare," there are no limits or boundaries, no line that separates the illusion from reality, no line he can't cross. In the scenes that follow, we see Caine and his friends murder the two Black men responsible for Harold's death. As the film moves toward its fatal ending, the most significant time is spent with Ronnie and her son, giving Caine's character a context other than that of the brutality of the streets, and allowing room for Ronnie's character to expand.

Although the brothers insist that they did not want to preach or propagandize, the few emotional breaks in the film have the effect of doing just that. During a group picnic and a father-son talk with a friend Sharif and his dad, Caine is given heartfelt advice about surviving. In his narration later, Caine admits that it actually touched him and stirred his thoughts. As we near the end of the film, and some of his friends think of leaving, Caine is prompted again to review his options: Stay in LA with O-Dog, leave with Ronnie and her son, or go to Kansas with Sharif. He finally decides to leave with Ronnie, and shortly after the decision, his life becomes infinitely more complicated. His final disasters are ignited by a young girl who claims to be pregnant with his child and a friend he assaults at a party for groping Ronnie. As loose ends are tied in the story, Ronnie and Caine visit Pernell in prison. He blesses their union and departure and asks Caine to take care of his son. "You teach him better than I taught you, man. Teach him the way we grew up was bullshit! All right?" Caine is then confronted by the pregnant girl's cousin, becomes enraged, and beats him mercilessly. Because of his behavior, his grandparents ask him to leave. He informs them that he will be leaving soon, but they will not let him stay there one more night. Saddened and tearful, he leaves. The police eventually get a copy of the tape from the friend seeking revenge.

The group helps Ronnie and Caine pack the car for Atlanta. As they exit Ronnie's house, we cut to the pregnant woman's cousin vowing to avenge her abuse and his beating. In the final sequence, we move from the car carrying the death squad and the group outside Ronnie's house

loading the van while Ronnie's son is riding his Big-Wheel on the side-walk. This is followed by a slow-motion shot of a car nearing the house; the sound of distant thunder rolling in forecasts the final bloody storm. As the car nears, we cut to Caine and his friends entering the house, to Ronnie's son on his Big-Wheel with the car behind him, to the car with four men inside, then to a medium shot of two hands protruding from the windows holding guns.

With a dramatic cut to black and a voice asking, "Yo! What's up now, partner?" shots ring out, and the camera swings wildly, showing sky, sidewalk, and houses as Sharif is killed and O-Dog skips sideways firing at the moving car. Ronnie's son, while on his Big-Wheel, observes the mas-sacre, and Caine runs out of the house. With two bullets in the chest, he lunges toward Ronnie's son, now frozen in place. Several edits tell the grim tale, and we cut to a medium long shot of the sidewalk, lawn, and house. Nearest the viewer is the overturned Big-Wheel, wheel still spin-ning. Caine lies on top of Ronnie's son, holding the boy's head, and behind them O-Dog walks over to inspect the two. In a point-of-view shot, we see Caine's back riddled with bullets, and cut to Ronnie, scream-ing, as she runs outside to retrieve her son, who is unharmed. A survivor holds Caine, as we hear his final voice-over. His last words are accompa-nied by the last beats of his heart and images of his past fill the screen. He ends by recalling the time his grandfather asked if he cared whether he lived or died. He admits that he does, but that it was now too late. We cut to the car leaving the scene, and, as one final shot rings out, we cut to black— with this, the film ends.

Left here with O-Dog and the horrors, we can't help thinking of Caine's early description of him: "America's nightmare," young, Black, didn't give a f—, an introduction that left the viewer little room for alternative read-ings. If this is the sentiment toward him from within the community, from his closest friend, what are viewers to think? O-Dog, like Bishop in *Juice*, is a problem for everyone, including his friends.

In this twist of the prescribed ending, the directors offer their final resistance. Brown responds to the morbid ending by saying, "Personally, I'm extremely sorry to see the film violate the code that says scumbags get their due."[25] For Allen and Albert Hughes, these characters are not at all aberrant; they are simply "real." The view of life they offer is not tamed or romanticized, and neither is the violence so consistently disseminated throughout the film. In the end, *Menace II Society* may leave audiences engulfed in a repugnant toxic fog. But, if asked, the filmmakers would claim that that's the way it is. Many would also conclude that these images

are not fictional at all but representative of some authentic portrayal, much like media reports, especially since the creators so closely resemble the characters in the film. As we endure the final moments of the film, drenched in the bloody horrors, we witness the hopes of a few destroyed.

Fighting violence with violence is one way of reading the film, according to Weinraub, who interviewed the twins and detailed their intentions: "We wanted to make a movie with a strong anti-violent theme and not like one of those Hollywood movies where hundreds of people die and everyone laughs and cheers. . . ."[26] It is apparent that the directors, from the onset, had every intention of disturbing the false sense of peace and of shaking up the audience. It is clear that Allen and Albert Hughes are talented filmmakers, as well as clever and daring social commentators. They used news footage early in the film to establish violence as a palpable social phenomenon. This proved that the news was as violent as any fiction they could create. That was a clever tactic. In those "real" scenes, as shocking as the film itself, violence frames the real world and the media that reflects it. "We wanted to make films about this concrete Vietnam," said Albert Hughes. "People kill over money, women, turf. People kill to show that they're men." [27] The rebellious use of the surveillance video and the mocking of *It's a Wonderful Life* surpasses everything we have seen before in relation to how media is used in these films. For these two filmmakers, there were no limits and no moral boundaries. *Menace II Society* stands as a film reaching the apogee of violence, one that wages war on how the film and television media handles violence. *Menace* sees itself as transcending it all, attaining some sort of higher, more elusive, truth.

Notes

1 Quendrith Johnson, "Born II Direct: The Hughes Brothers," *DGA Magazine* (July–August 1995): 21.

2 Ibid.

3 Nelson George, "Menaces to Society: Brothers Grim—the Hugheses' Film Is Hip-Hop Dark," *Village Voice*, 25 May 1993, 21.

4 Ibid.

5 Ibid.

6 David Denby, "Mean Streets," *New York*, 31 May 1993, 55.

7 Bernard Weinraub, "Twins Movie-Making Vision: Fighting Violence With Violence," *New York Times*, 10 June 1993, sec. C, p. 13.

8 Robert Marriott, "Burden of Proof," *Village Voice*, 25 May 1993, 22.

9 Ibid.

10 Paula Massood, "Menace II Society," *Cineaste* vol. 20, no. 2 (1993): 44.

11 Terrence Rafferty, "Dead End," *New Yorker*, 31 May 1993, 161.

12 Playthell Benjamin, "S.O.S.(Same Ol' Shit!)," *Village Voice*, 25 May 1993, 23.

13 Georgia Brown, "Badlands," *Village Voice*, 1 June 1993, 52.

14 Ibid.

15 Rafferty, "Dead End," 160.

16 Denby, "Mean Streets," 55.

17 Amy Taubin, "Girl N the Hood," *Sight and Sound* (August 1993): 17.

18 George, "Menaces to Society," 21.

19 Ibid.

20 Brown, "Badlands," 52.

21 Denby, "Mean Streets," 55.

22 Frank Krutnik, *In a Lonely Street: Film Noir, Genre, Masculinity* (New York Routledge, 1991), 214.

23 Rafferty, "Dead End," 160.

24 Johnson, "Born II Direct," 21.

25 Brown, "Badlands," 52.

26 Weinraub, "Twins Movie-Making Vision," 13.

27 Ibid., 14.

Chapter Seven

Clockers

Spike Lee, 1995

"All human beings are periodically tested by the power of the universe. Whether you're an athlete, entertainer, businessperson, etc., how one performs under extreme duress, how one performs under pressure is the true measure of one's spirit, heart and desire."[1]

Spike Lee

Spike Lee's *Clockers* (1995) is based on the Richard Price novel of the same name published in 1992. This is the final film in the series of six. It represents a culmination of our themes and demonstrates the movement's evolution almost ten years after its inception. Although similar themes persist, the film offers a contrasting view of the future of young Black males and of African American cinema. The now not-so-new Black urban genre was nearing its tenth anniversary, and many were wondering where it was headed, which directors would sustain its momentum in either popular or critical terms, and who would mentor its continued evolution or assimilation into American mainstream media. Until now, all of the films discussed here have been debut features, but *Clockers* is Lee's eighth film. It is an artistically mature film, an in-depth exploration of a Black male coming-of-age story, and for many, the most profound exploration of the gangster character in African American cinema thus far. With Lee's earlier call for diversifying the genre still resonating, this film presented an exciting opportunity for audiences and critics. "*Clockers* was," according to Leonard Quart, "Lee's first film to enter the territory of what Ed Guerrero has called the "ghettocentric" genre of films, like *New Jack City* (1991) and *Boys N the Hood* (1991), a genre which is, in different ways, based on action, violence, and crime."[2] How would mainstream audiences respond to another 'hood film, albeit at the hands of an established director?

Clockers is acknowledged by many as a work exemplifying Lee's development as an artist. Critics not only praised the film's technique, they labeled the work as one that spoke intelligently about its complex and possibly overused subject. "*Clockers* marks one of those welcomed occasions," reported Anthony Lane, "on which Spike Lee has got hold of material that enthuses him into a style."[3] As praise mounted, it was easy to see that Lee had revived interest in the dominant urban theme. "But the film," notes Richard Schickel, "is more than a murder mystery and more than a study in character conflict. At its best, it is an intense and complex portrait of an urban landscape on which the movies' gaze has not often fallen."[4] Lee had established himself as an important figure and force in American independent and commercial filmmaking. Often credited with igniting the contemporary movement in African American cinema in the mid-1980s, Lee had reached another peak with this film. Quart outlines some of the film's imperfections but says that "with *Clockers*, Spike Lee has made his most deeply felt, emotionally arresting, and socially significant film."[5] Since his first feature, Lee has been a dedicated, prolific, and innovative artist. He, more than any other contemporary Black filmmaker, has diversified his themes throughout the decade. Lee confirms, in an interview with Richard Setlowe, the importance of his artistic development and personal goals: "With a lot of my peers, there are three or four years between feature films. I just want to go from film to film to film. Not just trying to churn them out, but at the same time trying to grow."[6]

Ironically, *Clockers* did not do as well at the theaters as the other films in the genre. It didn't have the predicted mass appeal. According to Quart, "The problem with selling *Clockers* as a 'hood' film was that, despite its shared subject matter with films like *Menace II Society* (1993), it was too imaginative, complex, and non-formulaic a work to be a hit with the general public."[7] Was this some sort of a mixed blessing for Lee? Was Lee really interested in making a box office hit with *Clockers*, or simply "doing the right thing"? Quart explores the issue further: "Part of the answer lies in the fact that though *Clockers* depicts a society permeated with violence, it never follows the traditional Hollywood genre formula of building the film around a tight, fast-paced narrative filled with revved-up chase sequences, elongated shoot-outs, tension-building cross-cutting, and ingeniously constructed killings."[8]

Lee's contributions to the contemporary African American movement are immense. Lee had aspirations not only to be a Black filmmaker, but an American filmmaker, with all the rights and privileges afforded his

White counterparts. Continually in the struggle, Lee never relaxed his ideals, never reclined because of rising fame, never believed that the fight was over—even though he had, by all reasonable estimations, made it. In the production materials disseminated for *Clockers*, we find this overview of his diverse career: "In less than a decade Lee has made the leap from independent upstart to important cultural figure, extending his creativity to the worlds of advertising and music videos as well as film."[9] Completely tuned in, and turned on, to the power of media, Lee created a niche for himself that offers audiences a bird's-eye view of African American life as he continues to develop new approaches to the American cinematic form. He remained intimately involved with the art and craft of filmmaking, often experimenting with lighting, manipulating the range of film colors, and developing various types of film stock or revising the texture of existing ones. Lee spends a great deal of time designing each film's look, color, texture, and depth. Memorable works include the crisp black-and-white edges in *She's Gotta Have It*; the rich and sexy tones in *Mo' Better Blues*; the shocking colors in *Crooklyn*; and the contrasting environments in *Clockers*, which was Malik Sayeed's first feature as director of photography. "Explaining his approach on *Clockers*, Sayeed remarked, "I tried to manipulate the texture of the film itself to give a feeling, especially in the projects, of something that has a lot more weight visually."[10]

As a political activist, Lee went where no contemporary African American director had gone before, tackling subjects on conflict within the Black community, ethnic differences and tensions in *School Daze*, *Do the Right Thing*, and *Jungle Fever*, and religion in *Malcolm X*. Lee, no stranger to controversy and conflict, feels that he has faced it all, navigating and surviving what could have been crippling adversities, opposition, and criticism throughout his career. In his book *By Any Means Necessary*, a phrase that also describes his attitude toward his work, he acknowledges his battles in relation to the making of *Malcolm X*. "The static, the resistance came from everywhere. From Warner Brothers, the Completion Bond Co., the Teamsters, High Minister of Black Culture and Ethics, Amiri Baraka and his gang, and the media. Everyone got in some swings."[11] Lee has obviously learned the most important lessons about media, how powerful it is, and how to use it to his advantage. Within the context of his films or outside promoting or defending their political and artistic positions, he is well aware of media's potential: "Presently in America a war is being fought. Forget about guns, planes, and bombs, the weapons from now on will be the newspapers, magazines, TV shows, radio and film."[12]

In many ways, *Clockers* can be read as a response to various forms of violence plaguing people in the American mass media and, in particular,

the effect on Blacks. Lee has also tackled the mainstream Hollywood system, shattering the oppressive glass ceiling. He has fought not only for aesthetic privileges, such as final cut and the right to direct *Malcolm X*, but, on a larger scale, for equal rights in general for Black artists and technicians. His contributions, for example, to the increased employment of Black people in the film industry during his career was, and continues to be, significant.

The NAACP published a report in September 1991 detailing the status of Blacks in the film and television industry. The report, "Out of Focus—Out of Sync," gave an in-depth view of the number of Blacks not in the industry. It is a critical document for a 1990s look at African American cinema, a decade that appears, at least on the surface, to be a prosperous time for Blacks in Hollywood. Unfortunately, what the figures reveal is significantly less optimistic. What is clear from the numbers is that while Blacks are indeed directing and starring in more mainstream feature films, there is still little change in the industry's power structure. What follows is a summary from the report:

> In a listing of "Hollywood Power Brokers" published in the May, 1991 issue of *PREMIERE* Magazine, there were only two Blacks listed out of 100 persons. Eddie Murphy was 22nd on the list and Spike Lee was 67th. Number 1 on the list was Super Agent Michael Ovitz, the head of CAA Agency, followed by CEOs of major studios, actors, producers, and directors. According to the article these are the people in Hollywood who have "the ability to make a film, to structure a deal, to bend the rules a little." The absence of representation of Blacks on the list is an indication of the exclusion of Blacks as participants in any significant manner in the mainstream of Hollywood.[13]

By far, Lee's greatest achievement is his ability to work in the world of big Hollywood studios while maintaining his own sense of style, his political posture, energy, and much of the artistic edges of an independent filmmaker. "So it is," says Ed Guerrero, "the tricky negotiation of this contradiction, the balancing act of rendering black life honestly while winning a popular audience and avoiding complete cooptation by dominant cinema, that will determine much about the direction and character of black film in the '90s."[14] This challenge, navigated successfully by Lee, enabled a productive relationship with his funding sources, one that was profitable to both studio and director, and, more importantly, to moviegoing audiences who benefit from the outcome.

Critics and film historians questioned whether the 1980s independent movement would achieve significant and lasting stylistic distinctions from

Hollywood conventions. Lee, among others, stands out as a director who has been successful at meeting the challenge in both American independent cinema and African American cinema. Independent cinema is often known for low budgets, and sometimes no-budget guerrilla, or underground, filmmaking. However, for filmmakers, this mode of filmmaking is also classified by its level of creative control and characterized more by a willingness to take risks. Lee has, indeed, taken many chances and has made significant advances in the art of American filmmaking. Using his unique interpretation of cinematic elements, such as his signature dolly, where the character and the camera move together on the same platform, Lee realizes no limits to filmmaking as a craft. This dolly shot has come to have reliable significance in relation to the character's thoughts and mood, or is used to spotlight or characterize a particular narrative dilemma. Seeds sewn in the 1980s from the independent movement and directors from film schools eventually bloomed in the 1990s mainstream. Lee broke into the mainstream with great charisma and was subsequently invited to join the club, but refused in his own unique way. Hollywood's priorities, however, were shifting, and that would make way for more Black directors and their stories.

A changing of the guard in Hollywood was only one of the determining factors that shaped the mood and expectations of 1980s' filmmakers and audiences. African American viewers had already been purchasing movie tickets for films that for the most part were ignoring their needs. They were ready for something that spoke directly to their existence, something significantly more meaningful and lasting than the Blaxploitation era of the 1970s. The changing technology would also play a part in making the way for African American cinema. The 1980s also saw an increase in the number of film screens in the United States. Robert Sklar outlines some of the numbers, noting that "the total of indoor screens rose by more than fifty percent during the decade, from 14,000 to over 22,000."[15] More screens meant that the theaters needed more films to project, and new talents entered the field hoping to make their mark. There were more first-time directors in this decade than ever, ready to meet the challenge. They had acquired and developed skills as spectators and were confident about what they wanted to do, and, because they had practiced their craft, were even more sure about how they would execute their stories.

Lee, director of *She's Gotta Have It* (1986), *School Daze* (1988), *Do the Right Thing* (1989), *Mo' Better Blues* (1990), *Jungle Fever* (1991), *Malcolm X* (1992), *Crooklyn* (1994), and *Clockers* (1995), had estab-

lished himself as one of America's most exciting new filmmakers. While we have now become accustomed to the release of several African American films a year, it must be noted that when Lee's first feature reached the theaters in 1986, it was quite an event. After this independent film became a commercial success, his second film, *School Daze*, was made with studio money. The film, however, maintained its independent and innovative style. Constantly reminded of Hollywood's long-time attitude and treatment of Blacks as subjects or as filmmakers, Lee did not go completely studio. He resisted artistic assimilation while finding new ways to stay in the game. Instead, he maintained a close and sometimes tense relationship with his funding sources.

Another nuance of Lee's narrative approach is his clever reformulation of stereotypes into more useful cinematic and cultural tools. This revised use of character sketches often comes under fire, as it can easily be misconstrued as an unproductive perpetuation of negative and harmful images of Blacks. The positive-versus-negative image debate has haunted Lee throughout his career, yet his so-called stereotypes have made significant headway in exposing the real and diverse textures of Black life. Ella Shohat and Robert Stam make note of his efforts: "Spike Lee's *School Daze* (1988) also applies stereotypes for its own purposes..."[16]

Lee has managed, and not without controversy, to defy aesthetic boundaries and restrictions and express his own vision of Black life and version of Black filmmaking. He emerges as an American filmmaker focused on bringing contemporary issues facing Black Americans to the mainstream screen. Refusing confinement to one theme, he has developed, in a relatively short period of time, a wide range of work: love stories, documentaries, interracial and intraracial conflict, music, religion, the family, and, finally with *Clockers*, drugs and crime in Black communities. Ironically, Lee has managed to maintain his independence in Hollywood. There are people still trying to decide whether he has sold out or is truly an independent at heart. What Lee has achieved in his own way is one version of the African American dream. Eric Perkins encapsulates Lee's place in history: "Lee's career has centered on sustaining the magic of the 'crossover formula,' while at the same time remaining true to an independent cinema tradition that spans the careers of filmmakers from Oscar Micheaux to Melvin Van Peebles."[17] Lee is not fond of the term "crossover" or what it insinuates. "Lee disputes the idea 'Jungle Fever' was a crossover film," says Setlowe, "in that it gives compassionate and realistic equal time to both its Brooklyn Italians and its Black characters in Harlem. Crossover—'I hate that word.'"[18]

This film was Lee's first urban drama to focus on drugs and crime in the Black community. *Clockers* is about a young man named Ronald, nicknamed Strike (Mekhi Phifer), and his life on the streets as a reluctant solider in one of the many drug armies that occupy Black communities in America. The film, however, is also about a neighborhood where families try to survive and raise their children. It is in this context that we see the effect of criminal activity. "A 'clocker,'" explained Price, "is a slang for the lowest level of drug dealer. He's called a clocker because he's out there around the clock. *Clockers* depicts the harsh realities faced by an entire generation of young African American males, growing up in the inner city streets of today's America and seizing opportunity in whatever form it comes."[19] This, however, is not the usual gangster fare.

As is usual for Lee, other narratives unfold in the midst of this intensely forceful and intricate human drama. The most significant is that of Victor, Strike's brother (Isaiah Washington), who is his opposite: a family man with two children, two jobs, cool-headed and hard-working, a regular attendant at church, and a good son. Victor, as the story begins, is a model Black man, seemingly the furthest and safest distance away from the life of street crime that his brother has chosen. Later in the narrative, though, Victor surprises the audience and the police by confessing to a neighborhood murder. This act sends him to prison as the main, yet unbelievable, suspect. The most difficult character in the film is Rodney (Delroy Lindo), Strike's boss, who is a cunning and abusive mentor. His role is often disturbing to the audience, but particularly to Strike. Andre (Keith David) is the Black police officer from the neighborhood, who still resides there; Rocco Klein (Harvey Keitel) and Larry Mazilli (John Turturro) play local White cops who openly utter racist remarks.

Lee develops each of these characters in different and often conflicting ways. Andre, for example, knows and cares for Strike and wants to see him get off the streets, yet his frustration leads to physical violence. While his behavior is difficult for viewers, the story develops the action methodically. It is set in motion when Andre fears that a younger boy who lives in his building, Tyrone, nicknamed Shorty (Pee Wee Love), will be seduced into a life of crime exemplified by Strike. Nonetheless, it is Andre who repeatedly tries to get Strike off the streets and out of town by encouraging him to get on a train—like the toy trains he loves so much. According to the film's publicity, "For Lee, *Clockers* was an opportunity to capture the diversity of those who live within the confines of the projects. 'It would be a fallacy to say everyone in the projects is on dope or pregnant at 13,' he said. 'We wanted to show the humanity that these people

have—and it's something that you might not necessarily see looking at the six o'clock news.'"[20]

The *Clockers* audience, while listening to a mix of blues and jazz, is greeted with graphic and horrific police photographs of young lifeless Black bodies riddled with bullets. The opening song, "People in Search of a Life," is a ballad performed by Marc Dorsey, and is in sharp contrast to the gruesome images. Again, according to the film's production information, "Visually inventive and remarkably realistic, the images serve as chilling testimony to the many lives cut short in the war of the streets. 'We did this for the full effect,' said Lee. 'We wanted people to know, even before they settled into their seats, that we weren't dealing with cartoon shootings, because when you take a life, it's forever.'"[21] At the end of this montage, we cut to "the projects," and in the distance we see a young man approaching. As he comes toward us and sits down, we note that he is sipping something from a bottle, obviously not beer. This is our introduction to the film's main character, Strike, a rather pleasant-looking young man. The first moments of the film establish his life as a clocker. The story revolves around the investigation of a murder conducted by two White police officers, Rocco, and Larry. Essentially, Strike is openly unhappy with his work on the benches. To keep him as a faithful employee, Rodney insists that he commit murder, thus giving him something to hold over Strike. Strike, intending to fulfill this request, arrives at the fated moment, and for some yet unknown reason, turns away and walks into a nearby bar and sits with his brother Victor. Shortly after this scene, the audience becomes aware that the murder has, in fact, been committed through a gruesome scene detailing the police examination of the body. The audience is kept in suspense as to the killer's identity until the end of the film. Even though Victor has confessed, everyone believes that Strike is the real culprit and that Victor has confessed to protect his younger brother.

Throughout the film, Strike is constructed as a sympathetic loner, one who bleeds internally almost daily, not from gunshots but from an ulcer. He is posited as a somewhat naïve young man, doing what he has to do to survive. He is also in many obvious and not-so-obvious ways distinguishable from the other Black males on the benches. Strike openly hates his existence and wants to escape it. His innocence is established in several ways: by his choice of beverages (chocolate milk), his love of toy trains, and by the fact that his only friend is a younger boy. Through the trains, he is able to escape the reality of daily life and, for this, he is constantly teased. Lee also uses music to contextualize his character, contrasting his

actions from those of his predecessors in the genre. In other words, Lee does not fill the film or veil Strike's character with rap rage or gangster mantras. "A collaboration between Bruce Hornsby and Chaka Kahn resulted in the stirring track heard at the conclusion of *Clockers*. 'Love Me Still,' a song about the sanctuary of love, is a significant punctuation to a film that explores violence, the drug culture and misdirected souls,"[22] explains the film's publicity material.

Shorty's mother plays an important role in the film. She represents the fierce guardian of future generations of Black males and defends her son without hesitation or fear. At one point, she slaps Strike in front of his friends. Nonetheless, Shorty gets closer and closer to Strike and is the only one permitted into Strike's apartment to see his train set. Lee develops this relationship in sharp contrast to Strike's life on the benches. Strike is never seen socializing with any of his associates; he is never placed in any significant family setting; he has no girlfriend. Strike's problems begin to escalate during the murder investigation spearheaded by Rocco. Rodney's growing suspicions about Strike cause further stress in their relationship. Rocco continues pressuring Strike and engineering events that position Strike as an informant in order to force Rodney's hand. He is counting on Rodney's suspicions to advance the case. "To Rocco Klein, the idea of Victor's punctuating years of exemplary living by committing such a cold-blooded act doesn't add up,"[23] says *Clockers* information. As the pressure mounts, Strike's stomach worsens, and he begins to cough up blood.

There are three media sequences in the film. The first (created especially for this film) is a rap music video where weapons are brandished, plus a commercial for malt liquor, both playing at the bar where Strike and Victor talk. The second is the video game called "Gangsta" (also created by Lee), which is given to Shorty as a gift from Strike. Finally, there is a documentary sequence about trains playing in Strike's apartment. The narrative importance and configuration of these media moments vary, and they do not have the same significance to the story or its main character, Strike. The rap video, while enhancing or heightening the violent situation at hand as Strike and Victor talk, also signifies the presence of the artifacts in Black culture. The malt liquor commercial is intended to be another blatant example of the proliferation of violence even in television commercials directed at Black audiences. Both are used to underline the media's contributions to urban violence. Lee talks about his intentions with the scenes: "This movie deals with the proliferation of violence and guns in our society, how movies, television, radio, music videos, gangsta

rap, malt liquor ads—how this whole culture promotes carrying Uzis and nine millimeters."[24]

The "Gangsta" video game is much more complex and has several functions in the story, and many interpretations. On one level it represents the mass media and its potential to aid in the development of gangster fantasies. This is the video's potential on the surface, and it offers the young boy an example to follow, a character to emulate, as we saw in *New Jack City* or *Juice*. This media moment, however, deals with a much younger generation. While we understand this coding from our experience with these previous films, its actual story, and the resemblance to the *Clockers* narrative, it suggests some deeper meaning. Finally, we focus our attention on a seemingly innocuous train documentary. While, in the midst of the story, it seems to offer little narrative significance, it does, however, reinforce Strike's love of trains and dreams of escape. It is posited as this gangster's media and sets Strike apart from previous gangster characters like Nino, Bishop, or O-Dog. Strike's train fantasy is meant as an awakening of a different sort of dream or desire. It is in this context that the sequences find their most profound meaning. The director's use of this particular form of media is important not only to the story at hand, but to the film's deeper agenda for the character, the community, and African American cinema. It is in this sequence that we find hope for both the genre and the Black youth it represents.

The first media encounter takes place early in the film. In the scene, we note the videos and the commercial playing on the television suspended over the bar. It features young Black men, all holding guns and chanting the words from a song called "Illa Killa." Strike and Victor talk as we cut to the videos. Their conversation is strange, considering that the two have not seen each other for some time, and is primarily about Strike's intended victim. Victor seems uninterested at first in his brother's tales and makes fun of him. Later, however, he says he knows someone who could do the job. Darryl (Steve White) is killed, Victor confesses, and the police investigate Strike and Rodney as the real villains.

The second encounter is the most unique, not only for this film in particular, but in African American cinema in general. It represents a new use of media where the need is so specific that the reflexive moment was made especially for the film. It takes the form of the video game, Gangsta, and is projected onto the inside of a visor, which acts as a screen. As we witness the first meaningful exchange between Strike and Shorty, the younger boy plays with the toy en route to the barbershop for an updated haircut. The Gangsta videogame has its own production team in the cred-

its for *Clockers*, and is supposed to be the latest toy. It begins with the title, Gangsta, which is revealed letter by letter via gunshots ricocheting off the screen. We cut to an animated image composed of a White police officer—far right—pointing a gun at four Black thugs on the left, two of them carrying guns. There are two boxes, red and green, controlled by the player, and, as we watch, Shorty moves the boxes from one face to another to select a player. The camera cuts to a long shot and zooms in on the animated "projects," similar to the real building configuration where Strike and Shorty live. The zoom continues as we near a young Black boy on foot approaching an officer now holding a Black youth at gunpoint. The child then turns right and walks past, headed toward a nearby bicycle. The young boy is now seen riding through the projects on the bicycle, pointing a gun. He rides over to a man moving around in front of a black car. He fires a shot that hits the man's chest, and we zoom in to the wound until the screen is completely red and the words "got 'cha!" appear on the screen.

At the moment of its introduction in the story, the full significance of the Gangsta video is not yet apparent. What the audience relates to at this point is the tone and nature of the video game, and it makes assumptions about what the gift will mean for Shorty or Strike. What is clear is that, soon after this gift, Shorty begins to emulate Strike, wearing similar clothes and sipping chocolate milk, Strike's favorite drink. The last video moment confirms Strike's love of trains, and it occurs shortly after Rodney's arrest by Rocco and Larry. They manage to insinuate that Strike has turned him in, and the audience becomes concerned for his safety. Seconds later, we cut to a low shot of a train speeding by, which in many ways signifies the speed at which Strike should be leaving town. The next shot is of the front of a train while an announcer describes the virtues of this particular model, as we cut to Strike sitting on his bed completing a letter to his landlord, instructing him to give Shorty his elaborate train set after his departure. As we hear the continuation of the television in the background, we observe Strike as he plays with his train set one last time, causing the cars to crash seconds before the end of the scene.

We can organize the use of these television sequences in the film into two categories: explosive in nature, as was the case with the rap videos and the malt liquor commercials, and the seemingly banal, in the form of the train sequence. Here Lee is making a point about the genres of popular images. Making and presenting the rap video and commercial in the extreme forces the audience to note their intention and brings what is

usually experienced as subtext to knock-'em-out text. In this light, their intentions and subversive nature are hard to miss. Harry Allen explains:

> In the commercial for The Bomb, *Clocker*'s fictional malt liquor, black people are seen guzzling down 40s to the gyrations of a scantily clad hottie. Meanwhile, in an anonymous music video, brothers flash loads of solidly high tech weaponry over rhymes and beats. You can't show people drinking alcohol in a TV commercial. You can show them holding it, admiring it, smiling at it. But not drinking it. Plus, no music video where artists show off as much firepower as the ones here do would ever get released by any record company or shown by any music video channel.[25]

There are several ways to experience the infrequent use of rap music in the film. Some in the audience might see it, in relation to the other music, as intrusive, or may experience it as a kind of punctuation. What is important is that one gets the sense that, at times, rap music presents a contrasting environment to the film's action. It is meant to be extreme at the appropriate times, to awaken the viewer already aware of the potential for violence. This is usually juxtaposed with a scene where the soundtrack is almost otherworldly or dreamlike. The point is that the violence is not metered out consistently with the rap rhythms usually found in most contemporary Black urban films. Allen concurs, referring to the burden of "reality" placed on African American filmmakers and not on White filmmakers: "This is why, for example, I applaud Spike liberally for including flights-of-fancy music by Des'ree and Seal in the score despite a feel many will consider incongruous."[26]

Throughout the film, Lee continually reminds the audience about encoded or embedded messages in certain forms of media. He has carefully woven it into the film's story and has taken the time to craft, for the audience's benefit, his own versions of commercials, rap videos, and video games, to further make his point. While Lee does not show a direct cause-and-effect relation to the commercials, he is quite explicit about Shorty's playing the Gangsta video game. The dangers are implied indirectly at first, and then directly as he replays the game's action in the "real-life" narrative. David Denby makes reference to this moment, noting its relation to the story. "A young boy watches a virtual-reality enactment of a kid like himself plugging someone—and later does just that."[27] Lee also places the film at the viewer's disposal as another form of media, offering its own message through the very same form. If Lee is indeed using media to fight media, how is this accomplished? His unreal, or super-real, reality is so sharp it defies real life. Amy Taubin explains: "Instead," she says, "he shoves his distrust of popular culture, and indeed, of narrative itself in our face."[28]

Lee's use of media has a very specific progression: it moves in the story from the morbid or macabre (opening photographs) to the dangerous (rap videos, commercial, and video game), and then to hopeful (television shows about trains). The movement between these various forms of media and their respective intentions gives Lee boundaries within which he must maneuver concerns while giving agency to the same media he critiques. He accomplishes this while realizing media's potential social value. He proves the case that media quotes media best, and what a clever way to critique. In other words, not all media is "bad"—it simply depends how it is used.

Lee's use of media within the film provides a more concentrated essence of its negative impact. This aspect of the film did not go unnoticed. "From the ghastly snapshots under the opening credits—crime-scene photos of young black male corpses—to the background glimpses of violent video games and music lips glamorizing gunpacking rappers, Lee announces his furious protest at the culture of violence that has decimated the black urban community,"[29] wrote David Ansen in *Newsweek*.

In the end, Lee does release us from this grip by offering Strike his freedom. Our last media element in the film signaled Strike's eventual escape. This is his way out and ours as well. It is not until we see Strike on the train at the end of the film, looking out at open spaces, that we reassess the moments that passed before as meaningful and not the way to another dead-end fantasy. It would not have been difficult for the audience, given the genre and the films that preceded this, to imagine Strike being carried away in a body bag by Rocco, Larry, or Andre.

Although it is Lee's contribution to the 'hood genre, *Clockers* made several attempts at maintaining its humanity and hope for Black urban males and their respective communities. Comments, such as Stanley Kauffmann's, testify to the film's achievements despite its morbid focus: "Spike Lee has often been chided for underplaying the subject of drugs in black America. Now he has made something that more than amends."[30] Lee did not ignore the problems facing Blacks in America. His career has revealed other aspects of Black life, and has celebrated the community. It was the right time for Lee to focus on crime, as is clear from the following quote: "Bleak, hallucinatory, and fearlessly heartfelt, *Clockers* is precisely what its director Spike Lee said he wanted it to be: 'The hood movie to end all hood movies.'"[31] Even as it depicts the inhumanity of drugs and crime, *Clockers* remains profoundly human, as Georgia Brown confirms: "Some may call this Spike's first genre film, but it's too personal and eccentric for that. Tender and generous, and surprisingly nonviolent given the subject, it's clearly meant to help real people through hard places."[32]

Another indication of the film's texture, and a key to its meaning, is the music. The music in *Clockers* complements the film's obvious musical style or rhythm. In fact, the film has been compared to the musical language and was dubbed by one critic as "An Anguished Rap Opera." The film's attitude and movements are not at all the usual gangster fare. "The language of *Clockers*," says Schickel, "is finally transformative, turning what might have been no more than a slice of mean streets realism into a sort of rap opera, in which pained recitative prepares the way for anguished (and curiously moving) arias."[33] We see this analogy used again: "I didn't believe in some of the things I saw in this movie," says Lane, "yet I somehow believed the movie. The weird chords that it picks out, unlikely combinations of hope and malevolence, make the right kind of noise for an age that is off-key."[34] *Clockers* transcends is competitors, transcends its genre, and attains what any good film can hope for, the continuation and improvement of the art of film as a means to tell stories. This is Lee's accomplishment, giving agency to his craft. That the film is not compared exclusively to the gangster genre, although it resembles its form, but to other forms of cinema, is a blessing. "The hallucinatory quality of the image is expressive of Strike's psyche and of the insane position in which he finds himself—having to live like a tough guy when he's barely out of childhood,"[35] says Taubin.

Lee approaches each story, each film, each character, differently. He allows no category, no film stock, and no budget to limit his ideals. He follows his own aesthetic path and creates his own tradition, building on the best the art of film has to offer, the best of the African American traditions, and the best of Hollywood. What he does is give us hope in much the same way as he navigated Strike's eventual survival. *Clockers* is a brotherly act. It offers more than "know-how"; it offers what I will call "show-how." In other words, the director shows us all how it should be done, how this material should be handled. That this film was not a commercial hit speaks more to contemporary audiences' appetite for action-oriented films, regardless of the race of the director or its characters. Lee is not alone in this battle to refocus our attention on other matters or reeducate audiences for more critical viewing.

Notes

1 Spike Lee, *By Any Means Necessary: The Trials and Tribulations of the Making of Malcolm X* (New York: Hyperion, 1992), preface.

2 Leonard Quart, "Spike Lee's Clockers: A Lament for the Urban Ghetto," *Cineaste* 22, no. 1 (1996): 9.

3 Anthony Lane, "Cracking Up," *New Yorker*, 18 September 1995, 107.

4 Richard Schickel, "An Anguished Rap Opera," *Time*, 18 September 1995, 108.

5 Quart, "Spike Lee's Clockers," 11.

6 Richard Setlowe, "Shiftin' Gears, Movin' out of the Hood: Black Filmmakers Expanding Horizons—and Expectations," *Daily Variety*, 8 October 1993, 16.

7 Quart, "Spike Lee's Clockers," 9.

8 Ibid., 11.

9 Universal MCA, "*Clockers*: Production Information," Universal City Studios, Inc. 1995, 9.

10 Ibid., 8.

11 Lee, By Any Means Necessary, Preface.

12 Ibid.

13 NAACP, "Out of Focus—Out of Sync (A Report on the Film and Television Industries)," 23 September 1991, 29.

14 Ed Guerrero, "Black Film: Mo' Better in the '90s," *Black Camera* (Spring/Summer 1991): 2.

15 Robert Sklar, *Movie-Made America: A Cultural History of American Movies* (New York: Vintage, 1994) 341.

16 Ella Shohat and Robert Stam, *Unthinking Eurocentrism* (New York: Routledge, 1994), 205.

17 Eric Perkins, "Renewing the African-American Cinema: The Films of Spike Lee" *Cineaste* 17, no. 4 (1990): 4.

18 Setlowe, "Shiftin' Gears," 16.

19 Universal MCA, "*Clockers*: Production Information," 2.

20 Ibid., 3.

21 Ibid., 4.

22 Ibid., 9.

23 Ibid., 3.

24 Ibid., 4.

25 Harry Allen, "Telling Time: On Spike, Strike, and the 'Reality' of Clockers," *Village Voice*, 3 October 1995, 84.

26 Ibid.

27 David Denby, "Hard Time," *New York*, 18 September 1995, 73.

28 Amy Taubin, "Clocking In: Two Critics Rate Spike Lee's Ultimate Hood Movie," *Village Voice*, 19 September 1995, 76.

29 David Ansen, "Last Exits in Brooklyn," *Newsweek*, 25 September 1995, 92.

30 Stanley Kauffmann, "Controlled Substances," *New Republic*, 2 October 1995, 38.

31 Taubin, "Clocking In," 71.

32 Georgia Brown, "Clocking In: Two Critics Rate Spike Lee's Ultimate Hood Movie," *Village Voice*, 19 September 1995, 76.

33 Schickel, "An Anguished Rap Opera," 108.

34 Lane, "Cracking Up," 108.

35 Taubin, "Clocking In," 76.

Chapter Eight

Some Conclusions

Contemporary African American cinema has successfully brought a Black American perspective to mainstream media. A secondary agenda has been the positing of critical notions, among other things, regarding the persistent point of view that mainstream media asserts in relation to Black Americans. We can now acknowledge that critiques begin with the very existence of these films, as they represent, directly or indirectly, a variety of attempts to deal with issues plaguing African Americans as citizens and spectators for the past hundred years. In this latter context, the concerns of African American cinema are primarily the way mainstream media omits, or regularly misrepresents, the real history, present-day challenges, and complex texture, or duality, of Black life. The media moments in each film discussed here highlight these points of view and concerns while maintaining the traditions and standards of the art form.

In many ways, what we have observed in the process of analyzing these films, particularly through intertextual, reflexive, self-conscious, or double-conscious moments, is the inoculation of a great number of Black urban youth against some of the exclusionary, racist, or stereotypical impulses transmitted through mainstream media. According to the directors whose work we have analyzed, Black urban youth deal with social realities that can literally kill not just hope, the American dream, or the human spirit, but people, families, and communities. In fact, their efforts on behalf of a generation of Black youth permeate these films and the genre and have brought more public attention to the issues than many other socially conscious acts. The use of media within each film's narrative framework represents, then, a cinematic vaccine, concocted by each director and offered in small yet powerful doses, to stimulate the mind's critical abilities and encourage a different kind of resistance.

"Generally speaking," says Ed Guerrero, in discussing Black films in relation to the dominant cinema, "these currents of opposition arise simply

because black filmmaking mediates the experiences of a marginalized, oppressed people."[1] As the body of work in the contemporary period increased, so did its potential to affect more sectors of society. As African American films appeared with more regularity, mainstream audiences experienced their existence as natural, their themes as more familiar, and their point of view as tangible rather than exceptional or unexpected. Contemporary African American cinema has placed Black American life on a more public historical and social platform and Black film in a more prosperous and productive context for the next hundred years.

One of the central elements of each film discussed here was Black spectatorship. There were serious questions, comments, and critiques about the relationship mainstream media has with Black Americans, as well as distinctions between its overt and covert practices. In *New Jack City*, for example, Van Peebles explores spectatorship through Nino Brown and *Scarface*. Singleton transmits a meaningful critique of television media through Doughboy in *Boyz N the Hood*, and, likewise, Harris' Chantel offers her comments on the same subject in *Just Another Girl on the I.R.T.* Dickerson returns us to the issues of spectatorship in *Juice* through Bishop's identification with Cagney's character in *White Heat* and seeing his friend Blizzard on the daily news. The Hughes Brothers reject the good-prevails-over-evil premises in *It's a Wonderful Life* and frighten us with O-Dog's use of the surveillance videotape in *Menace II Society*. In *Clockers,* Lee creates his own exaggerated version of rap videos, computer games, and television commercials to emphasize their destructiveness and prevalence in our culture.

What these activities accomplish in the complex terrain of each film is the tuning-in of audiences to the pervasive intent of media. What they also do, whether individually or as a group, is remind us of the potentially destructive notions embedded seamlessly in mainstream media. Each director has examined, among other social urgencies, how media affects the lives of vulnerable Black youth already living a heartbeat away from a life of criminal activities, and inches away from the lure of it. These films insist that more attention needs to be given to Blacks who live worlds away from the promise of the mythical American dream. This, in my assessment, is the best answer for questions about prevalent urban themes. Since media so readily disseminates such myths, it is essential that conflicts be mediated by and through the very same media.

Mario Van Peebles, John Singleton, Ernest Dickerson, Leslie Harris, the Hughes Brothers, and Spike Lee have devised opportunities that encourage viewers to adopt a position that, at once, identifies with, and

resists, the characters' actions. By placing these real-life tragedies in the cinematic experience, each director has cultivated a generation of critical spectators. We, as viewers, are urged to understand, through a complex narrative process that goes far beyond the desire to identify with or distinguish from the character in question, the larger historical and political context of the characters and story at hand. Using Doughboy as one example, we find that, while distinction may be the final outcome, we have nonetheless developed a more lasting relationship with him. What this film has given us is time and reason to identify with some of his actions, but more importantly, the larger national context of his existence. One point often missed by critics of the genre is that, given the issues they present and circumstances they depict, these films cannot present easy answers or comply with positive image requirements.

All of the films discussed here were intended to have mass appeal. They were formulated as commercial works for distribution to mainstream audiences, and, simultaneously, each had the intention of attending to the needs of Black audiences, most especially the young people who might be affected by, or in many cases are negatively represented by, mainstream media. Included in these harsh cautionary tales are warnings about the dangers embedded in film itself, used here as the conduit of the critique. Media is powerful and its lure is irresistible. Its larger-than-life presentation is an attractive and seductive spectacle that gets everyone's attention, over and over again.

Guerrero discusses the relationship between the cinema and the circus: "Both are built," he says, "on the suspension of disbelief and rely on large doses of spectacle. Both forms also mask a certain hard reality with the veil of aesthestic pleasure, illusion, and trickery."[2] No form of media, then, should be exempt from scrutiny. When writing about *Clockers*, Anthony Lane makes this statement: "Lee's movie is broad and well built enough to stand up straight; we don't need to be taken aside and reminded that this is only a story."[3] The fact, however, is that we do, and on a regular basis.

The other perspective offered by these films is criticism about television images that lets us know how conscious Black people are about the state of their lives and the media's insensitivity to their daily challenges. Doughboy and Chantel remind us of this. Since this newest facet of American film has in large part been successfully directed toward Black urban youth, the primary consumers of such forms of media, the issues are critical. That so many of these films originate from Black males can also be seen as an act of self-preservation, a different sort of peer pressure.

The early 1990s marked an important moment in African American cinema. Observers of Black urban media were watching to see whether the studios would run out of interest and money for Black directors or whether audiences would dwindle from boredom with the themes. More Black-directed films were released in 1991 than had been produced in the previous decade. Contemporary African American cinema was moving further and faster than any other period in Black film history. Films had gained attention and acceptance in a way that promoted hope for the period but also for assimilation into the mainstream as well. It was a time that reassured us that contemporary African American cinema would not go the way of Blaxploitation. Film and television, integral and vital elements of American culture, act as conduits of social norms and expectations and the promotion, and sometimes production, of the mythical American dream. Unfortunately, media also excludes, negates, or reduces the lives of marginalized people. This naturally affects all Americans, particularly ethnic Americans.

For Black American filmmakers, mainstream media has played an essential role in their development as spectators and in their dual lives, or double-consciousness, as Black Americans, and, subsequently, is expressed in their creative work. Understandably, as important aspects of Black life and a Black American perspective find their way into the Hollywood mainstream, issues pertaining to the role of media surface as a topic or theme. What, then, is the nature of the critique? It falls primarily into two categories: identification and resistance. Contemporary African American cinema has made several significant allegations about this very popular and highly regarded medium. We have seen characters charge television news coverage with obscuring Black communities. We have seen the victims of advertising, music videos, video games, and larger-than-life fictional gangsters. We have witnessed and heard from Black spectators.

In an effort to demystify the notion of race embedded in the term "African American cinema," it is time to include some provocative thoughts from *"Race," Writing, and Difference*, edited by Henry Louis Gates, Jr. The most important and, surprisingly, simplest point made in the book is that "race, as a meaningful criterion within the biological sciences, has long been recognized to be a fiction. When we speak of 'the white race' or 'the black race,' 'the Jewish race' or 'the Aryan race,' we speak in biological misnomers and, more generally, in metaphors."[4] Therefore, the impetus to separate these films from American media cannot entirely be found in notions of race. With this knowledge in mind, what are the significant foundations and arguments for delineating, obscuring, or marginalizing a

people and their artistic by-products? Gates continues the point: "The relation between 'racial character' and these sorts of characteristics has been inscribed through tropes of race, lending the sanction of God, biology, or the natural order to even presumably unbiased descriptions of cultural tendencies and differences."[5] It is this "perceived" difference, then, that acts as one of the barriers, or a partition, between contemporary African American cinema and mainstream films in general. That these barriers exist first and foremost in life is the central point of this national tragedy. In truth, there is very little "African" in African American cinema. However, while the films share similarities with established media formulas, many Blacks have been denied certain rights, access, and privileges based on race. "What separates Gates from many others in the field is his view that the Afro-American identity was forged primarily in America rather than in Africa,"[6] wrote Alvin Sanoff in 1992.

Race, no matter what forms its foundation, cannot be so easily dismissed. Navigating its notions, whether perceived or inscribed, is a part of our culture, embedded deep in our history and, consequently, in many of our systems and institutions. Today, it remains a stage upon which certain contemporary social rituals must unfold. For Guerrero, the most important context for Black films in mainstream media "continues to be the social construction and contestation of race and how we as a nation negotiate our turbulent, multivalent racial definitions and power relations."[7] The issue of race, then, must be used to contextualize African American cinema's content, but not its form.

African American cinema, like the doubleness of Black life in America, exists in two realities. The convergence of these realities is evident in the films. Their intersection is, I contend, marked by the reflexive or intertextual moment. Characters are observed in the process of what for them is "normal life," which involves moving between these worlds. While doing so, they narrate for us their states of consciousness, at times acknowledging the duality that produces profound moments of self-consciousness. In some cases, this was captured by the narrative's media moment, but in others, the self-consciousness occurred in the audience. The images created to expose this self-consiousness in African American cinema take us beneath the kinetic surface of each film's story; in essence, they violate the volatile presentation. How, then, are we able to read the signs? In fact, what are they? For Robert Stam, reflexivity provides a way of deciphering the codes. "Like gods at play, reflexive artists see themselves as unbound by life as it is perceived (Reality), by stories as they have been told (Genre), or by a nebulous probability (Verisimilitude),"[8] he writes.

Intertextuality and reflexivity do not offer quick and ready-made answers to the questions posed here. However, they do provide another layer of discourse.

In concluding our discussions, we note that we have made an effort, and some progress, in moving away from isolating notions of race and difference in contemporary African American cinema. Let us, then, consider African American films American cinema. Let us look at each film's framework as an evolution of a long and strong tradition in American filmmaking, easily decipherable as the continuation of one of the many American genres. As new texts on American cinema were published in the mid-to-late 1990s, the inclusion of African American films provided a stronger foundation for the argument that this is, above all else, an American art form. *Movie-Made America* and *New American Cinema* are two books that exemplify this trend. In film after film, Black directors have made countless efforts, and achieved as many successes, in locating their work in American filmmaking. We have seen the evidence of their intentions and accomplishments. This is clearly marked by the use of classical films as text and subtext in most of the films discussed here. In countless interviews, Black directors have spoken of the impact the films from the classical Hollywood period had on their lives and consequently on their work. Deeper ties were revealed when filmmakers discussed the effect classical films had on them as spectators. The availability of films as areas of study in many academic institutions, coupled with a desire to bring Black images to mainstream audiences for popular consumption, fosters a particular kind of political and artistic awareness. In each case, reflexive and intertextual moments represent the results— by-products if you will of this synthesis. Contemporary Black filmmakers are proof of an important process and evolution in American filmmaking. These cultural artifacts are there for us to examine and will reside in video stores, libraries, and archives as a foundation to encourage future generations. Those of us who have witnessed this synthesis have experienced firsthand the striking end products as this period of filmmaking unfolded on American culture.

Assimilation seems to be one way to classify the trend for the future. By assimilation I mean, quite literally, to absorb African American cinema into the culture, and, in this case, mainstream film culture. This assimilation, then, is a process by which African American cinema is seen as American cinema. A process that sees, with some regularity, Black themes in mainstream cinema. A process that witnesses an evolution and, more importantly, the eradication of previously laid boundaries. We have al-

ready seen the signs of this. F. Gary Gray's *Set It Off*, Forest Whitaker's *Waiting to Exhale*, and Spike Lee's *He Got Game* have gone beyond some of the boundaries established earlier in the period. *He Got Game* brings the Black father back to the family without judgment, and both *Waiting to Exhale* and *Set It Off* make it everyone's responsibility to put Black women on the commercial screen. However, the struggle is by no means over, according to Lee, who revisits many of the political and artistic concerns facing mainstream Blacks in *Bamboozled* (2000). The film featured Damon Wayans, Jada Pinkett Smith, Michael Rapaport, Tommy Davidson, and Savion Glover in a very complex critique of a mainstream media system where Blacks "seem" to have some power. So, for the next hundred years, Black filmmakers will continue to make films inside and outside the Hollywood system. Films that will prioritize not only the historical concerns, and aspirations, of Black Americans, but evolving concerns as well. *Bamboozled*, for example, speaks to a seemingly integrated Hollywood structure but exposes the real seat of power, which continues to exclude Blacks. Lee explains his point best: "That's why I have a white character say in the film to a black writer, 'I know niggers better than you.'[9] Contemporary African American cinema represents many things. It can be a critique, a corrective, or simply a formulation of the next step in an evolutionary process that recognizes the needs and talents of Black people while maintaining its roots in American filmmaking.

Notes

1 Ed Guerrero, "A Circus of Dreams and Lies: The Black Film Wave at Middle Age," in *The New American Cinema,* ed. Jon Lewis (Durham: Duke University Press, 1998), 335.

2 Ibid., 329.

3 Anthony Lane, "Cracking Up," *New Yorker,* 18 September 1995, 108.

4 Henry Louis Gates, Jr., *"Race," Writing, and Difference* (Chicago: The University of Chicago Press, 1986), 4.

5 Ibid., 5.

6 Alvin P. Sanoff, "Sorting Out the African legacy: Henry Gates Aims to Resurrect Black Studies," *U.S. News & World Report,* 16 March 1992, 63.

7 Guerrero, "A Circus of Dreams and Lies," 329.

8 Robert Stam, *Reflexivity in Film and Literature* (New York: Columbia University Press, 1992), 129.

9 Allison Samuels, "Spike's Minstrel Show," *Newsweek,* 2 October 2000, 75.

Bibliography

Balio, Tino. *The American Film Industry*. Madison: The University of Wisconsin Press, 1985.

Bogle, Donald. *Blacks in American Films and Television*. New York: Simon & Schuster, 1988.

———— *Toms, Coons, Mulattoes, Mammies, and Bucks*. New York: Continuum, 1991.

Brecht, Bertolt. *Brecht on Theatre*. New York: Hill and Wang, 1964.

Caughie, John, ed. *Theories of Authorship*. New York: Routledge, 1990.

Cripps, Thomas. *Black Film as Genre*. Bloomington: Indiana University Press, 1978.

———— *Making Movies Black*. New York: Oxford University Press, 1993.

———— *Slow Fade to Black*. New York: Oxford University Press, 1993.

Diawara, Manthia, ed. *Black American Cinema*. New York: Routledge, 1993.

Fanon, Frantz. *The Wretched of the Earth*. New York: Grove Press, 1963.

Gates, Jr., Henry Louis. *"Race," Writing, and Difference*. Chicago: The University of Chicago Press, 1986.

———— *The Signifying Monkey*. New York: Oxford University Press, 1988.

Gilroy, Paul. *The Black Atlantic: Modernity and Double Consciousness*. Cambridge: Harvard University Press, 1993.

Gray, Herman. *Watching Race: Television and the Struggle for "Blackness."* Minneapolis: The University of Minnesota Press, 1995.

Guerrero, Ed. *Framing Blackness: The African American Image in Film.* Philadelphia: Temple University Press, 1993.

hooks, bell. *Black Looks: Race and Representation.* Boston: South End Press, 1992.

Klotman, Phyllis Rauch, ed. *Screenplays of the African American Experience.* Bloomington: Indiana University Press, 1991.

Klotman, Phyllis R., and Gloria J. Gibson. *Frame by Frame II: A Filmography of the African American Image, 1978–1994.* Bloomington: Indiana University Press, 1997.

Krutnik, Frank. *In a Lonely Street: Film Noir, Genre, Masculinity.* New York: Routledge, 1991.

Lee, Spike. *By Any Means Necessary: The Trials and Tribulations of the Making of Malcolm X.* New York: Hyperion, 1992.

Lewis, Jon, ed. *The New American Cinema.* Durham: Duke University Press, 1998.

Mapp, Edward. *Blacks in American Films: Today and Yesterday.* Metuchen, N.J.: Scarecrow Press, 1972.

McMillan, Terry. *Five for Five: The Films of Spike Lee.* New York: Workman, 1991.

Meier, August, and Elliot Rudwick. *From Plantation to Ghetto.* New York: Hill and Wang, 1976.

Miller, Randall M, ed. *The Kaleidoscopic Lens: How Hollywood Views Ethnic Groups.* New Jersey: Jerome S. Ozer, 1980.

Min-ha, Trinh. *Woman, Native, Other.* Bloomington: Indiana University Press, 1989.

Morrison, Toni. *Playing in the Dark: Whiteness and the Literary Imagination.* New York: Vintage, 1992.

Null, Gary. *Black Hollywood.* New York: Citadel Press, 1970.

Omi, Michael and Howard Winant. *Racial Formation in the United States.* New York: Routledge, 1994.

Patterson, Lindsay, ed. *Black Films and Filmmakers*. New York: Dodd, Mead, 1975.

Reid, Mark. *Redefining Black Film*. Berkeley: Berkeley: University of California Press, 1993.

Rhines, Jesse Algeron. *Black Film/White Money*. New Jersey: Rutgers University Press, 1996.

Shohat, Ella, and Robert Stam. *Unthinking Eurocentrism*. New York: Routledge, 1994.

Sklar, Robert. *Movie-Made America: A Cultural History of American Movies*. New York: Vintage, 1994.

Snead, James. *White Screen/Black Images: Hollywood from the Dark Side*. New York: Routledge, 1994.

Stam, Robert. *Reflexivity in Film and Literature*. New York: Columbia University Press, 1992.

Stam, Robert, Robert Burgoyne, and Sandy Flitterman-Lewis. *New Vocabularies in Film Semiotics*. New York: Routledge, 1992.

Vogel, Amos. *Film as Subversive Art*. New York: Random House, 1974.

Wood, Robin. *Hollywood from Vietnam to Reagan*. New York: Columbia University Press, 1986.

Articles

Allen, Harry. "Telling Time: On Strike and the 'Reality' of Clockers." *Village Voice*, 3 October 1995, 84.

Ansen, David. "Last Exits in Brooklyn." *Newsweek*, 25 September 1995, 92.

Austin, Regina. ""The Black Community," Its Lawbreakers, and a Politics of Identification." *Southern California Law Review*, 65, No. 4 (May 1992): 1777.

Benjamin, Playthell. "S.O.S. (Same Ol' Shit!)." *Village Voice*, 25 May 1993, 23.

Biskind, Peter. "The Colour of Money." *Sight and Sound* (August 1992): 6.

Brown, Georgia. "Badlands." *Village Voice*, 1 June 1993, 52.

———— "Clocking In: Two Critics Rate Spike Lee's Ultimate Hood Movie." *Village Voice*, 19 September 1995, 71.

———— "How We Grew." *Village Voice*, 21 January 1992, 52.

Brunette, Peter. "Singleton's Street Noises." *Sight and Sound* (August 1991): 13.

Bush, Anita, and Andrea King. "Paramount Marketing Plan for 'Juice' Comes Under Fire." *Hollywood Reporter*, 10 June 1992, 1.

Canby, Vincent. "Brains, a Gift of Gab and Headed for Trouble." *New York Times,* 19 March 1993, sec. C, 12.

Chambers, Veronica. "Finally, a Black Woman Behind the Camera." *Glamour*, March 1992, 111.

Cohn, Lawrence. "All-Time Film Rental Champs." *Variety,* 24 February 1992, 125.

———— "Blacks Taking the Helm." *Variety*, 18 March 1991, 1.

Coleman, Beth. "She's Gotta Do It." *Village Voice*, 23 March 1993, 58.

Davis, Zeinabu Irene. "Black Independent or Hollywood Iconoclast?" *Cineaste* 17, no.4 (1990): 36–37.

Denby, David. "Hard Time." *New York*, 18 September 1995, 72–73.

———— "Mean Streets." *New York*, 31 May 1993, 54–55.

———— "Portrait of the Artist as a Big Bore." *New* York, 5 April 1993, 60–61.

Dyson, Michael. "Out of the Ghetto." *Sight and Sound* (October 1992): 18–21.

Gates, Jr., Henry Louis. "Generation X." *Black Film Review* 7, no. 3 (1992): 4–17.

———— "Must Buppiehood Cost Homeboy His Soul?" *New York Times*, 1 March 1992, sec. H, 11–13.

Godfrey, Rebecca. "Straight Outta Sea Island." *Off-Hollywood Report* (1992): 17.

George, Nelson. "Box Office Riot." *Village Voice*, 26 March 1991, 25.

———— "Buppies, B-Boys, Baps, and Bohos." *Village Voice*, 17 March 1992, 25–27.

————"Forty Acres and an Empire." *Village Voice*, 7 August 1990, 61.

———— "Menaces to Society." *Village Voice*, 25 May 1993, 21.

Goodwin Barnes, Trudy. "Charles Burnett: Unmasking Black Media." *Visions* 1, no. 3 (Summer 1991): 24–28.

Guerrero, Ed. "Black Film: Mo' Better in the '90s." *Black Camera* (Spring/ Summer 1991): 2–3.

Healy, Mark. "Fly Girls on Film." *New York*, 25 January 1993, 24.

Hoberman, J. "Howl." *Village Voice*, 16 July 1991, 58.

Hruska, Bronwen, and Graham Rayman. "On the Outside, Looking In." *New York Times*, 21 February 1993, 17.

Johnson, Quendrith. "Born II Direct: The Hughes Brothers." *DGA Magazine* (July–August 1995): 18–22.

Jones, Jacquie. "Crime and Punishment." *Black Film Review* 6, no. 4 (1991): 10.

———— "From Jump Street." *Black Film Review* 6, no. 4 (1991): 12–15.

———— "Peer Pressure." *Black Film Review* 7, no. 2 (1992): 24–28.

———— "The New Ghetto Aesthetic." *Wide Angle* 13: no. 3, 4 (July–October 1991): 32–44.

Kauffmann, Stanley. "Controlled Substances." *New Republic*, 2 October 1995, 38–39.

Kennedy, Lisa. "The Black Familiar." *Village Voice*, 16 October 1990, 62.

Kermode, Mark. "Reviews: Boyz N the Hood." *Sight and Sound* (November 1991): 37–38.

King, Andrea. "Black Filmmakers Blast Media." *Hollywood Reporter*, 21 February 1992, cover, 6.

Klawans, Stuart. "Clockers: Theremin- An Electronic Odyssey." *The Nation*, 9 October 1995, 399–400.

Klein, Andy. "P.O.V.: Color Adjustment." *Hollywood Reporter*, 15 June 1992, 9.

Lane, Anthony. "Cracking Up." *New Yorker*, 18 September 1995, 107–108.

Maslin, Janet. "Making a Movie Take the Rap for the Violence That It Attracts." *New York Times*, 22 January 1992, sec. C, 13.

———— "Under Scrutiny: TV Images of Blacks." *New York Times*, 29 January 1992, sec. C, p. 15.

Masood, Paula. "Menace II Society." *Cineaste* 20, no. 2 (1993): 44–45.

McCarthy, Todd. "Just Another Girl on the I.R.T." *Variety*, 21 September 1992, 84–85.

———— "Boyz N the Hood." *Variety*, 20 May 1991, 38–39.

McHenry, Doug, and George Jackson. "Missing the Big Picture." *New York Times*, 26 March 1991, sec. A, 23.

Perkins, Eric. "Renewing the African-American Cinema: The Films of Spike Lee." *Cineaste* 17, no. 4 (1990): 4–8.

Phillips, Julie. "Growing Up Black and Female: Leslie Harris's Just Another Girl on the I.R.T." *Cineaste* 19, no. 4 (1993): 86–87.

Proctor, Lett. "A Rage in Hollywood." *Black Film Review* 6, no. 4 (1991): 9.

Quart, Leonard. "Spike Lee's Clockers: A Lament for the Urban Ghetto" *Cineaste* 22, no. 1 (1996): 9.

Rafferty, Terrence. "Dead End." *New Yorker*, 31 May 1993, 160–162.

———— "Tunnel Vision." *New Yorker*, 22 March 1993, 102–105.

Rich, B. Ruby. "In the Eyes of the Beholder." *Village Voice*, 28 January 1992, 60.

Riggs, Marlon. "Meet the New Willie Horton." *New York Times*, 6 March, 1992, sec. A, 33.

Rhoter, Larry. "An All-Black Film (Except the Audience)." *New York Times*, 20 November 1990, sec. C, 15.

———— "The Star of 'New Jack City' is Building on Its Success." *New York Times*, 27 March 1991, sec. C, 13.

Robb, David. "NAACP Report Hits Studios for 'Invisible Ceiling.'" *Variety*, 25 July 1990, 12.

Rule, Sheila. "Director Defies Odds with First Feature, 'Daughters of the Dust.'" *New York Times*, 12 February 1992, sec. C, 15.

Salaam, Kalamu Ya. "Marlon Riggs." *Black Film Review* 7, no. 3 (1992): 4–8.

Schickel, Richard. "An Anguished Rap Opera." *Time*, 18 September 1995, 108.

Setlowe, Richard. "Black Filmmakers Shiftin' Gears, Movin' out of the Hood: Black Filmmakers Expanding Horizons—and Expectations." *Daily Variety*, 8 October 1993, 11.

Singleton, John. "The Fire This Time." *Premiere* (July 1992): 74–75.

Sklar, Robert. "What is the Right Thing." *Cineaste* 17, no. 4 (1991): 32–33.

Sragow, Michael. "An Explorer of the Black Mind Looks Back, but Not in Anger." *New York Times*, 1 January 1995, sec. H, 9.

Tate, Greg. "Flygirl on Film." *Village Voice*, 23 March 1993, 58.

Taubin, Amy. "Clockers." *Sight and Sound* (October 1995): 45.

——— "Girl N the Hood." *Sight and Sound* (August 1993): 16–17.

——— "Living for the City." *Village Voice*, 28 January 1992, 56.

——— "TV of Color." *Village Voice*, 4 February 1992, 60.

Taylor, Clyde. "The Positive Void." *Black Film Review* 7, no. 2 (1992): 18–23.

Thompson, Anne. "Charting the Gray Area of 'Crossover' Pictures." *Variety*, 18 March 1991, 105–106.

Van Peebles, Mario and Melvin Van Peebles. "For 'New Jack City,' It's the Same Old Story." *New York Times*, 31 March 1991, sec. H, 9.

Williams, Lena. "Spike Lee Says Money from Blacks Saved 'X'." *New York Times*, 20 May 1992, sec. C, 15.

Special Issues/Reports/Documents

The Business of Film. "The New Genre: Black Filmmakers in the 90s." June/July 1991.

NAACP. "Out of Focus—Out of Sync (A Report on the Film and Television Industries)." 23 September 1991.

Universal MCA. "Clockers: Production Information." Universal City Studios, Inc., 1995.

Index

The History & Art of Cinema

Frank Beaver, *General Editor*

Framing Film is committed to serious, high-quality film studies on topics of national and international interest. The series is open to a full range of scholarly methodologies and analytical approaches in the examination of cinema art and history, including topics on film theory, film and society, gender and race, politics. Cutting-edge studies and diverse points of view are particularly encouraged.

For additional information about the series or for the submission of manuscripts, please contact:

Peter Lang Publishing, Inc.
Acquisitions Department
275 Seventh Avenue, 28th floor
New York, NY 10001

To order other books in this series, please contact our Customer Service Department at:

(800) 770-LANG (within the U.S.)
(212) 647-7706 (outside the U.S.)
(212) 647-7707 FAX

Or browse online by series at:

WWW.PETERLANGUSA.COM